ITALIAN RENAISSANCE DRAWINGS

from the Musée du Louvre, Paris

Roman, Tuscan, and Emilian Schools 1500–1575

The Metropolitan Museum of Art

October 11, 1974 – January 5, 1975

Copyright © 1974 by The Metropolitan Museum of Art
Design by Peter Oldenburg
Composition by Finn Typographic Service, Inc.
Printing by The Meriden Gravure Company

LIBRARY OF CONGRESS CATALOGING IN PUBLICATION DATA

Bacou, Roseline.
 Italian Renaissance drawings from the Musée du Lou-
vre, Paris: Roman, Tuscan, and Emilian Schools, 1500–
1575.

 "Catalogue notices by Roseline Bacou and Françoise
Viatte."
 Includes bibliographies.
 1. Drawings, Renaissance—Exhibitions. I. Viatte, Fran-
çoise, joint author. II. Paris. Musée national du Louvre. III.
New York (City). Metropolitan Museum of Art. IV. Title.

NC255.B32 741.9'45 74-12141
ISBN 0-87099-094-2

Preface

These beautiful Italian Renaissance drawings, lent to us by the Cabinet des Dessins of the Musée du Louvre, come as the latest wave of French generosity to The Metropolitan Museum of Art. They follow upon the glorious tapestries lent to us earlier this year for the exhibition *Masterpieces of Tapestry from the Fourteenth to the Sixteenth Century*. Loan exhibitions of such great works of art are the first positive results of recent agreements between the National Museums of France and the Metropolitan Museum intended to facilitate the exchange of works of art and of personnel between France and America.

In October, 1973, the Metropolitan Museum sent to Paris an exhibition that included its finest drawings by French artists of the nineteenth century; the present splendid selection of drawings by Italian Renaissance masters from the Louvre is France's response to New York's loan to Paris. For it we owe a great debt of gratitude to Jean Chatelain, Director of the Museums of France, and to Maurice Sérullaz, Chief Curator of the Cabinet des Dessins of the Louvre.

THOMAS HOVING
Director
The Metropolitan Museum of Art

In central Italy at the High Renaissance draughtsmanship reached a peak of formal and functional perfection. Painters and sculptors were then first and foremost draughtsmen, and by drawing—*il disegno*—was meant not only the drawn preparation for a finished work of art, but also the underlying intellectual plan of that work. Draughtsmanship was a means both to analyze the outside world and to create a new ideal artistic world. These two functions of drawing—examination and creation—were investigated by the great earlier Renaissance master, Leonardo da Vinci, and they were perfected by his spiritual followers, Michelangelo and Raphael, whose drawings dominate this exhibition.

These two artists were active above all in Rome, the most important artistic center in sixteenth-century Italy. It was in Rome that their influence was predominant, Michelangelo teaching, aiding, or influencing Sebastiano del Piombo, Daniele da Volterra, and Battista Franco, while Raphael influenced by his example or instruction Giulio Romano, Perino del Vaga, and Polidoro da Caravaggio. Each of the last three artists developed highly personal styles out of the apparently contradictory tendencies toward decorative refinement and vigorous dramatization that were inherent in the last works of Raphael. The examples set by Michelangelo and Raphael illuminated the whole course of art in sixteenth-century Rome, explaining, for example, the artistic obligations as well as the originality of such a fine draughtsman as Taddeo Zuccaro.

In Tuscany, the Florentine School maintained a vigorous individuality. Following Fra Bartolomeo, Andrea del Sarto set the example for classic figure draughtsmanship, establishing norms of obedience and disobedience for Florentines for the next half century, for Sogliani, Pontormo, Bacchiacca, Salviati, and Naldini. Siena, for her part, produced artists—thus draughtsmen—of great originality. Sodoma was Sienese by adoption and shared local celebrity with the idiosyncratic Beccafumi, while Peruzzi found favor and scope in Rome.

Parma, the Emilian center, produced in Correggio the most painterly of draughtsmen, and then, by contrast, Parmigianino, who was heir to all the grace of Correggio, but who expressed himself most felicitously in calligraphic terms, with pen and

ink. The elegance cultivated at the school of Parma was much savored in contemporary France, at Fontainebleau, where the Emilians Francesco Primaticcio and Niccolò dell'Abbate executed important decorative schemes.

Venice and the north of Italy, where *il disegno* did not have as fundamental an importance in the artistic process, have been omitted from this survey intended to celebrate the art of draughtsmanship at its greatest splendor in the High Renaissance.

We owe this celebration of a glorious period in the history of Italian art to a French institution, the Cabinet des Dessins of the Musée du Louvre. Very few other European collections, and no American source, could supply a comparable group of drawings to illustrate Italian High Renaissance draughtsmanship, chosen not only for their historical relevance, but also for their intrinsic, independent beauty.

Early evidence of French partiality for Italian art is apparent in the commissions of Primaticcio and Niccolò at Fontainebleau. Many of their drawings, which were esteemed at the time, passed into French collections and eventually in the royal collection, the Cabinet du Roi. In the pages that follow, Roseline Bacou traces the history of this great collection, nucleus of the Cabinet des Dessins, which from its inception was first and foremost a collection of Italian drawings.

With three exceptions the drawings exhibited here have been chosen from material already in the Cabinet des Dessins by the end of the eighteenth century. Of these three, two were purchased in the past century (No. 31, Michelangelo, and No. 61, Raphael), and one acquired as recently as 1970 (No. 70, Sodoma). They testify to a policy of selective acquisition that guarantees for the Cabinet des Dessins its traditional place as one of the greatest, and perhaps the greatest, among European collections of drawings.

We at The Metropolitan Museum of Art are deeply grateful to our friends and colleagues Maurice Sérullaz, Conservateur en chef, and to Roseline Bacou, Conservateur au Cabinet des Dessins, Musée du Louvre, for their great generosity in sending to New York this incomparable selection, the finest group of Italian High Renaissance drawings ever to be shown in America.

JACOB BEAN
Curator of Drawings
The Metropolitan Museum of Art

In October 1973 the Louvre presented in the Pavillon de Flore a remarkable group of French drawings of the nineteenth and early twentieth centuries lent by the Department of Drawings of The Metropolitan Museum of Art. The importance of this exhibition, which enjoyed great critical and popular success, was a brilliant justification and the first positive result of agreements made between the Direction des Musées de France and the Trustees of the Metropolitan Museum concerning a series of exchange exhibitions intended to make known to a wider public the artistic riches of these two great institutions. The present exhibition constitutes the second part of the exchange program devoted to drawings.

Italian drawings of the Renaissance, specifically Tuscan, Roman, and Emilian drawings of the first half of the sixteenth century, are the subject of this exhibition. The selection was made by Jacob Bean, Curator of Drawings at the Metropolitan Museum, working with Maurice Sérullaz, Conservateur en Chef du Cabinet des Dessins, and myself. If this choice underlines, as we hope, the very high quality of the representation of the Italian Schools in the Louvre's portfolios, it also reveals our friend Jacob Bean's comprehensive knowledge of our collection. Prior to his return to New York in 1960, he participated for a number of years in the activities of the Cabinet des Dessins.

None of the drawings shown here has ever been seen in America. Some are celebrated and have been repeatedly studied and reproduced in the literature of the Italian Renaissance, while others have been recently rediscovered through new attributions and are exhibited for the first time anywhere. With three exceptions (Nos. 31, 61, and 70) all the drawings exhibited entered the French national collection before the beginning of the nineteenth century. It has seemed to us that the interest in such an exhibition would be increased if it offered not only a choice of splendid drawings but, as well, a testimony to the history of the collecting of Italian drawings in France in the course of the seventeenth and eighteenth centuries, through an evocation of the great acquisitions of the French royal collection of drawings, the Cabinet du Roi.

The royal collection of drawings may be said to have been established in 1671, in which year Louis XIV purchased the collection of Everhard Jabach. A native of Cologne who had settled in Paris by 1638, Jabach brought together, in an *hôtel* designed by Bullet in the rue Saint-Merry, an ensemble of works of art of the most exceptional quality, acquired in France, in Italy, in Germany, and also in England at the time of the dispersal (1650–53) of the collection of King Charles I. Amongst the

most important groups of drawings purchased by Jabach were pages from the *Libro de' Disegni* compiled in the sixteenth century by Giorgio Vasari, from which comes, for example, the *Stigmatization of St. Francis* by Girolamo Muziano (No. 33), still on its mount decorated by Vasari. To Jabach belonged as well a number of Fontainebleau School drawings from a collection formed at the beginning of the seventeenth century by the Abbé Desneux de La Noue, such as the *Masquerade at Persepolis* (No. 59), Primaticcio's *modello* for the decoration of the Chambre de la Duchesse d'Etampes at Fontainebleau. In 1671 financial difficulties obliged Jabach to sell to the King his paintings, which count today amongst the jewels of the Louvre, and his 5,542 drawings. The manuscript inventory drawn up at the time of the sale lists the drawings that Jabach considered the most precious in his collection: of 2,631 items thus inventoried, 2,258 were Italian drawings of the Renaissance and of the first half of the seventeenth century. Not the least of these is Raphael's superb cartoon for his painting *St. Catherine of Alexandria* (No. 62). It is interesting to note that certain attributions in this inventory that were overlooked in later years have today been verified, such as the attribution to Parmigianino of one of the most important drawings of his early years, the *Rape of Europa* (No. 39). Certain of the Jabach drawings that were remounted in the eighteenth century, thus losing the record of their provenance, have been recently identified in the manuscript inventory with their correct attribution, such as the *St. Luke* of Perino del Vaga (No. 47) and the *House of Sleep* by Taddeo Zuccaro (No. 74). Amongst the 2,911 drawings that Jabach judged of secondary interest and called "le rebut de ma collection," modern specialists have discovered drawings as important as Michelangelo's *Crucifixion* (No. 32) and Sebastiano del Piombo's *St. Agatha* (No. 69).

The second great purchase under the *Ancien Régime* of Italian Renaissance drawings was made in 1775. In the reign of Louis XV the royal administration was negligent, in particular on the occasion of the Crozat sale, in 1741; Cardinal Fleury, opposed to any purchase at this celebrated sale announced that the King already had "assez de fatras." However, a marvelous new opportunity presented itself in 1775 when the finest group of drawings assembled in the eighteenth century by a private collector, Pierre-Jean Mariette, was put on the auction block. A Parisian bourgeois, the son and the grandson of publishers and print dealers, Mariette was the perfect connoisseur, acutely responsive to the quality of a drawing, to the accuracy of its attribution, to its state of preservation, and to its provenance. Of course, Mariette was occasionally mistaken, but his intellectual probity was exemplary, as

were his passion and fervor as a collector. His celebrated blue mount can be recognized on fourteen sheets presented here, including Andrea del Sarto's study for the *Zacharias* in the Chiostro dello Scalzo (No. 66), the cartoon for one of the angels in Raphael's *Expulsion of Heliodorus* (No. 64), the sheet of studies by Correggio for the apse of S. Giovanni Evangelista (No. 15), and the *River Fishermen Pulling in Nets* by Giulio Romano for the Palazzo del Te (No. 23). More than one thousand drawings, the majority of them Italian, were acquired for the Cabinet du Roi at the Mariette sale.

At the Revolution the royal collections became the property of the Nation and, assembled at the Louvre, constituted the Museum National. To the nucleus of the Cabinet des Dessins of the Louvre, the Cabinet du Roi, which in 1792 numbered more than ten thousand items, were added the confiscated artistic property of certain *émigrés*; many private collections formed in the second half of the eighteenth century entered the Louvre at this time. The most important group of Italian drawings was that collected by the Comte de Saint-Morys, who had himself engraved a number of the drawings in his possession (Nos. 54 and 55). A study of the acquisitions of the Cabinet du Roi under the *Ancien Régime* and of the Museum National during the Revolution reveals the predilection of French *amateurs* for Italian draughtsmanship of the sixteenth century; the drawings of Michelangelo and Raphael, and of Correggio and Parmigianino, served as the basis of the very definition of artistic beauty and as the standard for all judgment of contemporary art. We should be grateful as well to the curiosity of these French collectors of the past for having saved from oblivion the drawings of such artists as Primaticcio, Niccolò dell'Abbate, Beccafumi, Lelio Orsi, Perino del Vaga, and Polidoro da Caravaggio, thereby assuring the survival of the work of these wonderfully gifted Italian draughtsmen.

ROSELINE BACOU
Conservateur au Cabinet des Dessins
Musée du Louvre

Catalogue Entries by

Roseline Bacou and Françoise Viatte

*Conservateurs au Cabinet des Dessins,
Musée du Louvre*

The bibliography for many of the celebrated drawings that figure in this exhibition is so extensive that in the concise entries for this catalogue it has been limited to essential, standard works. Reference is also made to old inventories and catalogues of the Musée du Louvre.

Works cited in abbreviated form are listed at the end of the catalogue entries.

NICCOLÒ DELL'ABBATE

Modena, about 1512–Fontainebleau 1571

1 *Group of Four Figures*

Pen and brown ink on beige paper.
7⁹⁄₁₆ x 11³⁄₁₆ in. (19.2 x 28.4 cm.).

PROVENANCE: Cabinet du Roi.
Inventaire 5894.

BIBLIOGRAPHY: S. Béguin, "Niccolò del-l'Abbate en France," *Art de France*, II, 1962, p. 136, note 61.

An important drawing that dates from the period of Niccolò's activity in France. The influence of Primaticcio, and specifically of his decorations for the Salle de Bal at Fontainebleau, is apparent in the amplitude of the forms and the grouping of the figures. The supple and nervous pen line is characteristic of Niccolò's drawing style around 1555 and is closely related to that of a drawing in the Musée Pincé at Angers representing Ceres standing between groups of reclining or seated divinities (S. Béguin, *L'Ecole de Fontainebleau*, exhibition catalogue, Paris, 1972, no. 12, repr.).

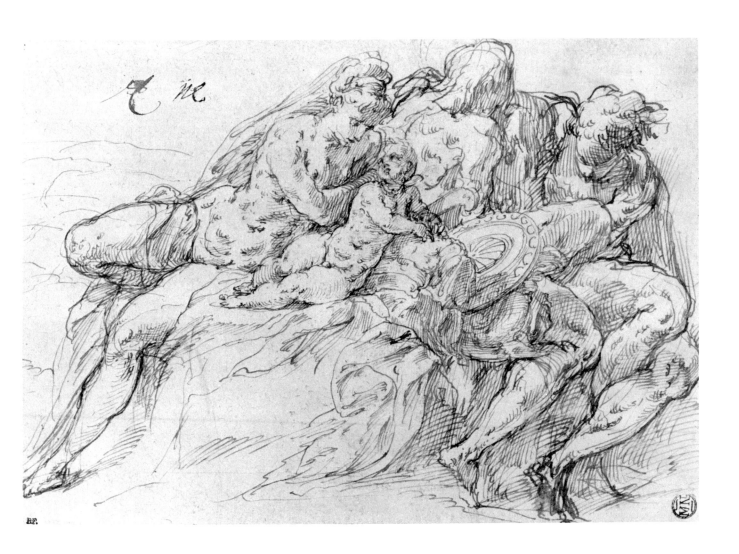

NICCOLÒ DELL'ABBATE

Modena, about 1512–Fontainebleau 1571

2 *The Annunciation*

Red chalk and red wash, heightened with white,
 on brownish paper. 6⅞ x 12³⁄₁₆ in.
 (17.5 x 31.0 cm.).

Inscribed in brush and red wash at upper right:
 Nicolas Labadj.

PROVENANCE: Everhard Jabach (Lugt 2961);
 Cabinet du Roi from 1671.
 Inventaire 5828.

BIBLIOGRAPHY: Jabach Inventory, I, no. 159
 (as Primaticcio); Reiset, 1866, no. 2;
 S. Béguin, *Niccolò dell'Abbate* (exhibition
 catalogue), Bologna, 1969, no. 54, repr.;
 S. Béguin, *Il Cinquecento francese*, Milan,
 1970, p. 83, pl. XIV; S. Béguin, *L'Ecole de
 Fontainebleau* (exhibition catalogue), Paris,
 1972, no. 8, repr.

Study for the *Annunciation* painted by Niccolò in the Chapel of the château at Fleury-en-Bière. The composition was engraved by Antoine Garnier as the work of Primaticcio in a set of seventeen engravings after the compositions at Fleury-en-Bière, published in 1646. Louis Dimier convincingly attributed to Niccolò this group of frescoes, which must date from before 1558 (*Le Primatice*, Paris, 1900, p. 73, no. 2); the presence of St. Cosmas in these decorations implies that they were painted during the lifetime of Cosme Clausse, Secrétaire des Finances under Henri II and owner of the château of Fleury-en-Bière. The Louvre possesses three further drawings for Fleury: a study for the *Pietà* (Inv. 5836) and studies of angels (Inv. 5842 and 5843).

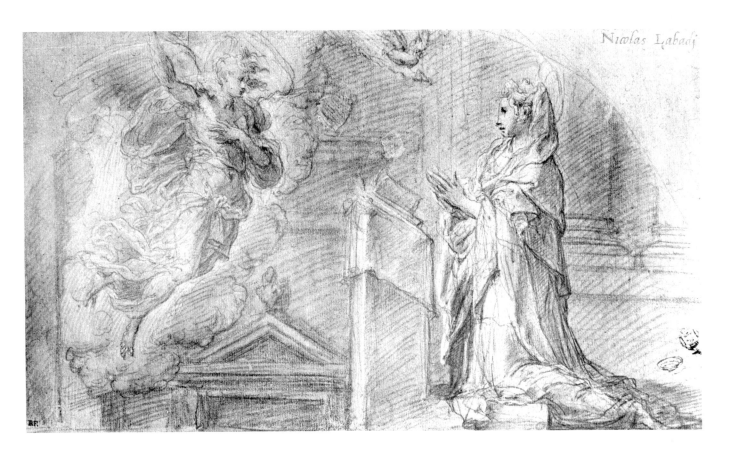

MICHELANGELO ANSELMI

Lucca or Siena, about 1491–Parma 1554/1556

3 *Head of a Young Man*

Red chalk, heightened with white.
13¾ x 10¾16 in. (35.0 x 25.9 cm.).

PROVENANCE: Pierre Crozat; Crozat sale, Paris, 1741, probably part of no. 342; P.-J. Mariette (Lugt 1852), his mount with cartouche: ANTONII CORREGIENSIS, *Fuit Petri Crozat, nunc P. J. Mariette;* Mariette sale, Paris, 1775, part of no. 119; Prince de Conti; Conti sale, Paris, 1777, no. 112; entered the Museum National during the Revolution.
Inventaire 5935.

BIBLIOGRAPHY: A. E. Popham, *Correggio's Drawings,* London, 1957, pp. 170–171, no. 11; A. G. Quintavalle, *Michelangelo Anselmi,* Parma, 1960, pp. 42, 121, repr. fig. 75; R. Bacou and F. Viatte, *Dessins de l'Ecole de Parme* (exhibition catalogue), Paris, 1964, no. 29.

The attribution to Correggio of this beautiful head study goes back to the eighteenth century. However, first Philip Pouncey and then A. E. Popham convincingly suggested that this is the work of Anselmi, an artist trained in Siena but active in Parma from 1520. Quintavalle proposed a connection for this drawing with paintings in the Galleria Nazionale, Parma, and S. Prospero in Reggio Emilia (repr. Quintavalle, 1960, figs. 65, 74). Anselmi's early activity in Parma coincides with Correggio's work in the church of S. Giovanni Evangelista.

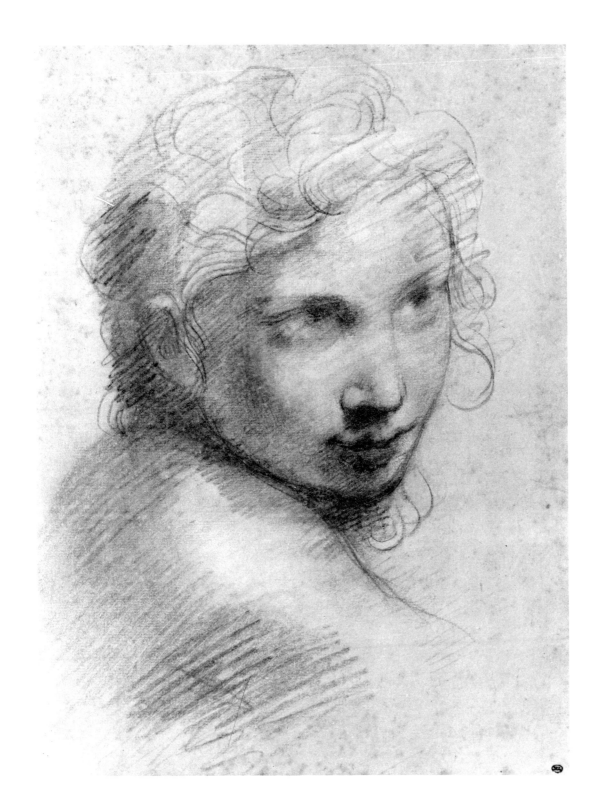

FRANCESCO UBERTINI, called BACCHIACCA

Florence 1494–Florence 1557

4 *Landscape with Cavalier Approaching a Castle*

Red chalk on brownish paper. 8¾₁₆ x 11¾ in.
(20.9 x 29.9 cm.).

PROVENANCE: Everhard Jabach (Lugt 2959 and
2953), with his gold border; Cabinet du Roi
from 1671.
Inventaire 11.038.

BIBLIOGRAPHY: Jabach Inventory, I, no. 35
(as Michelangelo); R. Bacou, *Dessins de
maîtres florentins et siennois* (exhibition
catalogue), Paris, 1955, no. 58; F. Viatte,
*Il Paesaggio nel disegno del cinquecento
europeo* (exhibition catalogue), Rome,
1972–1973, under no. 46.

This unpublished drawing was first associated with Bacchiacca by Roseline Bacou in 1955, as were two other landscape drawings also classed at the Louvre amongst the anonymous Italian drawings (Inv. 11.041 and 11.043). These three drawings are stylistically related to a group of some thirty sheets of similar technique and dimensions conserved in the Uffizi. Most of the Uffizi drawings represent landscapes, some of which are identifiable thanks to their inscriptions and two of which are dated 1527. Though some appear to be later and by another hand, a great many of the drawings must have formed part of an album. On stylistic grounds they appear to be the work of a Florentine artist and datable about 1525–30. Fraenckel, in his 1935 monograph on Andrea del Sarto, is responsible for the reconstruction of this ensemble, while the attribution of these Uffizi drawings to Bacchiacca was made by Luisa Marcucci (*Bollettino d'Arte*, 1958). More recently Federico Zeri has suggested that the artist may be his "Master of the Kress Landscapes," by comparing the drawings with the three panels in the National Gallery, Washington. (F. Zeri, "Eccentrici fiorentini," *Bollettino d'Arte*, 1962, pp. 228–231).

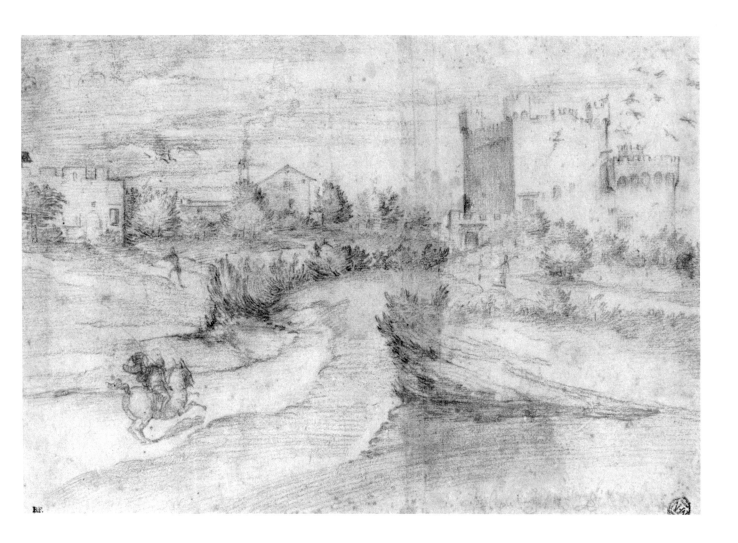

BACCIO BANDINELLI

Florence 1493–Florence 1560

5 *Lamentation on the Dead Christ*

Pen and brown ink. 9¹¹⁄₁₆ x 15 in. (24.6 x 38.2 cm.).

PROVENANCE: Purchased by the Museum National in Paris, 18 germinal, an II (1794). Inventaire 117.

It is difficult to connect this drawing, wrongly attributed to Battista Franco in eighteenth-century inventories, with any surviving sculpture by Bandinelli, though the themes of the Pietà and the Lamentation on the Dead Christ are subjects the artist represented on several occasions. Certain drawings that represent such subjects (notably Inv. 103 in the Louvre) offer such striking similarities in technique and bas-relief-like composition that they may be associated with a specific project, such as the embossed silver cross ornamented with Passion scenes that Bandinelli's father, the goldsmith Michelangelo di Viviano, was to have executed after his son's designs. This cross was left unfinished at his death in 1528 (A. Forlani, *I Disegni italiani del cinquecento*, Venice, n.d., p. 180, no. 40).

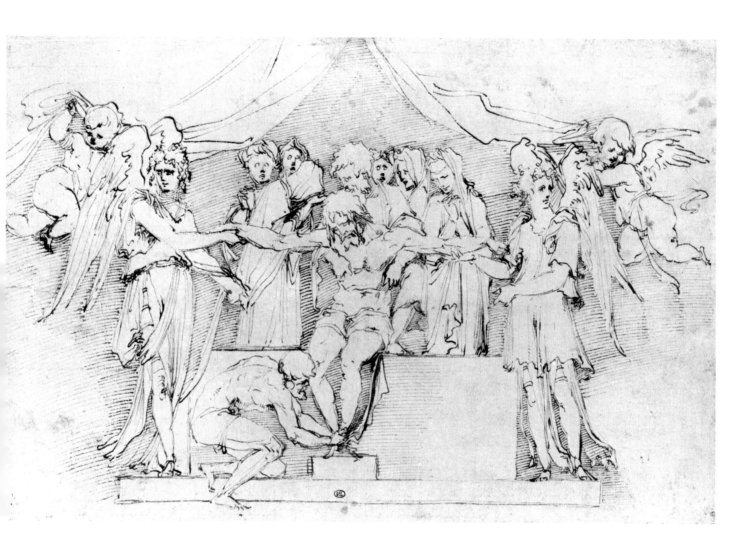

BACCIO BANDINELLI

Florence 1493–Florence 1560

6 *Seated Woman Sewing*

Red chalk. 8¹³⁄₁₆ x 7⅞ in. (22.4 x 20.0 cm.).

PROVENANCE: Everhard Jabach (Lugt 2959 and 2953), with his gold border; Cabinet du Roi from 1671. Inventaire 118.

BIBLIOGRAPHY: Jabach Inventory, I, no. 62 (as Bandinelli); Parker, 1956, under nos. 77–79; M. G. Ciardi-Duprè, "Per la cronologia dei disegni di Baccio Bandinelli fino al 1540," *Commentari*, XVII, 1–3, 1966, p. 168, note 14.

This study of a seated woman sewing with two children behind her, probably drawn after nature, has been connected by K. T. Parker with three red chalk drawings by Bandinelli at the Ashmolean Museum, Oxford, that may be of the same model. Parker considers these drawings to be early works, while M. G. Ciardi-Dupré prefers to place the Louvre drawing around 1525–30, before the artist's departure for Rome.

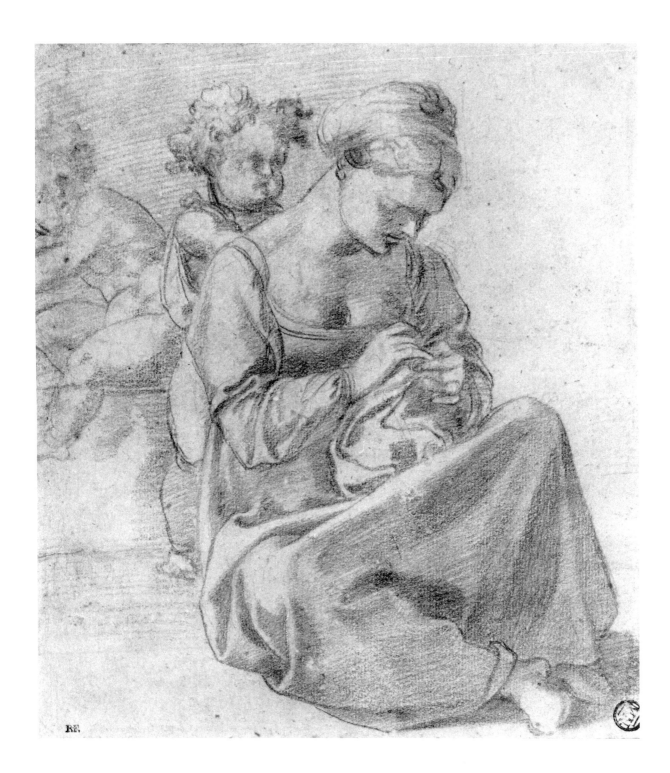

BACCIO DELLA PORTA, called FRA BARTOLOMEO

Florence 1472–Florence 1517

7 *Standing Figure of the Virgin*

Black and white chalk on brown paper; vertical red chalk line to left of center. 11⅝ x 8⁷⁄₁₆ in. (29.5 x 21.4 cm.).

Inscribed in pen and brown ink at lower right: *Giorgion.*

PROVENANCE: Entered the Museum National during the Revolution. Inventaire 223.

BIBLIOGRAPHY: F. Knapp, *Fra Bartolommeo und die Schule von S. Marco,* Halle, 1903, p. 316, fig. 36; H. von der Gabelentz, *Fra Bartolommeo und die Florentiner Renaissance,* II, Leipzig, 1922, p. 158, no. 388, fig. 6; Venturi, IX, 1, p. 246 note; W. Ames, "Sketches for an Assumption by Fra Bartolommeo," *Gazette des Beaux Arts,* 1944, p. 215; R. Bacou, *Dessins de maîtres florentins et siennois* (exhibition catalogue), Paris, 1955, no. 15; Berenson, 1961, I, p. 233; II, no. 483; III, fig. 414.

Study for the Virgin in the *Assumption,* formerly in the Kaiser Friedrich Museum, Berlin, executed about 1508, the upper part of which was painted by Fra Bartolomeo's assistant Albertinelli. Both in technique and in the amplitude of the forms, the drawing is a characteristic example of Fra Bartolomeo's mature style. Further studies connectible with the *Assumption* are in two albums of drawings by the artist, formerly in Weimar, now in the Museum Boymans-van Beuningen, Rotterdam (Berenson, 1961, I, p. 235): a study for the whole composition (I, fol. 199 recto), for the Virgin (I, fol. 199 verso), and for the angels (I, fol. 75; II, fol. 106 recto and verso).

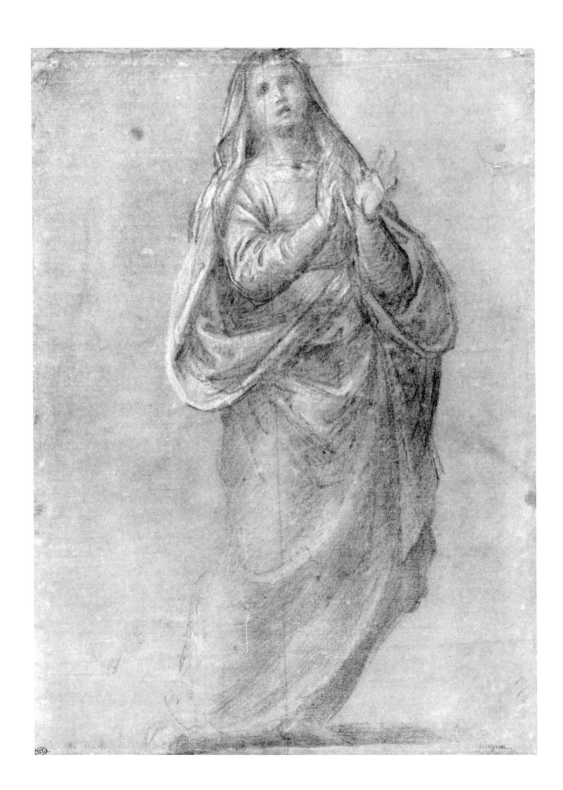

BACCIO DELLA PORTA, called FRA BARTOLOMEO

Florence 1472–Florence 1517

8 *Head of an Old Man*

Red chalk. 5⅜ x 6½ in. (13.7 x 16.6 cm.).

Inscribed in pen and brown ink: *y 1*; and in pencil: *Portrait de Bonaroti*.

PROVENANCE: Entered the Museum National during the Revolution.
Inventaire 212.

BIBLIOGRAPHY: Reiset, 1866, no. 212; F. Knapp, *Andrea del Sarto*, Leipzig, 1907, p. 135; H. von der Gabelentz, *Fra Bartolommeo und die Florentiner Renaissance*, II, Leipzig, 1922, p. 148, no. 359; Berenson, 1961, I, p. 425; II, no. 158; Freedberg, 1963, pp. 257–258, fig. 186; P. Pouncey, "B. Berenson, *I Disegni dei Pittori fiorentini*" (review), *Master Drawings*, II, 3, 1964, p. 282, pl. 29.

Both Fra Bartolomeo and Andrea del Sarto have been proposed as the author of this impressive drawing of an unidentified model which cannot be connected with any painted work. The realism and the intelligent placement of the head on the page testify in favor of Andrea, but a comparison with his head study (No. 68) underlines the absence in this drawing of those energetic, stylized accents that characterize Andrea's draughtsmanship. The subtlety of the modeling, which reveals considerable psychological penetration, is worthy of Fra Bartolomeo.

The attribution of the drawing to Andrea was proposed in 1903 by Berenson, followed by Knapp in 1907; in 1922 Gabelentz assigned it to the School of Andrea; neither Freedberg in 1963 nor Shearman in 1965 retained it in their lists of Andrea's work. The traditional attribution to Fra Bartolomeo, which appears in the inventory drawn up at the time when this drawing entered the Louvre collection, as well as in Reiset's 1866 catalogue, was very convincingly reaffirmed in 1964 by Philip Pouncey.

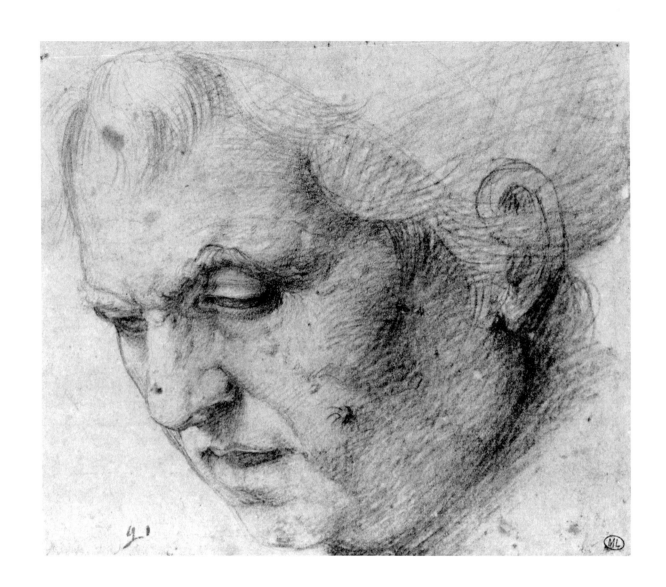

DOMENICO BECCAFUMI

Valdibiena, near Siena, about 1486–Siena 1551

9 *Three Figure Studies*

(a) *Study of a Headless Female Figure*
Pen and light brown ink, light brown wash.
5⅛ x 2⅛ in. (13.1 x 5.4 cm.).

(b) *Male Nude Seen from the Rear*
Pen and brown ink. 10½ x 7⅛ in.
(26.7 x 18.1 cm.).

(c) *Study of a Standing Female Nude*
Pen and brown ink. 8⅞ x 3½ in.
(22.6 x 8.9 cm.).

BIBLIOGRAPHY: J. Judey, *Domenico Beccafumi*,
Berlin, 1932, p. 144, no. 163; O. Kurz,
"Giorgio Vasari's *Libro de' Disegni*," *Old
Master Drawings*, XII, December, 1937,
p. 39; D. Sanminiatelli, *Domenico Becca-
fumi*, Milan, 1967, p. 155, no. 78.

These three drawings were mounted together by Giorgio Vasari, who admired Beccafumi and possessed a number of the Sienese artist's drawings in his own *Libro de' Disegni*. Sanminiatelli assigns the three sketches to the years 1520–25, soon after Beccafumi's trip to Rome. The female nude, drawn from the example of the antique torso sketched at the left, corresponds to a figure type that is encountered several times in the artist's paintings. The study of the male nude, a sketch most characteristic of Beccafumi's draughtsmanship, is related to a figure of Hercules in the ceiling fresco, the *Choice of Hercules*, in the Palazzo Bindi Sergardi in Siena, decorated in 1524–25 (repr. Sanminiatelli, pl. 31h).

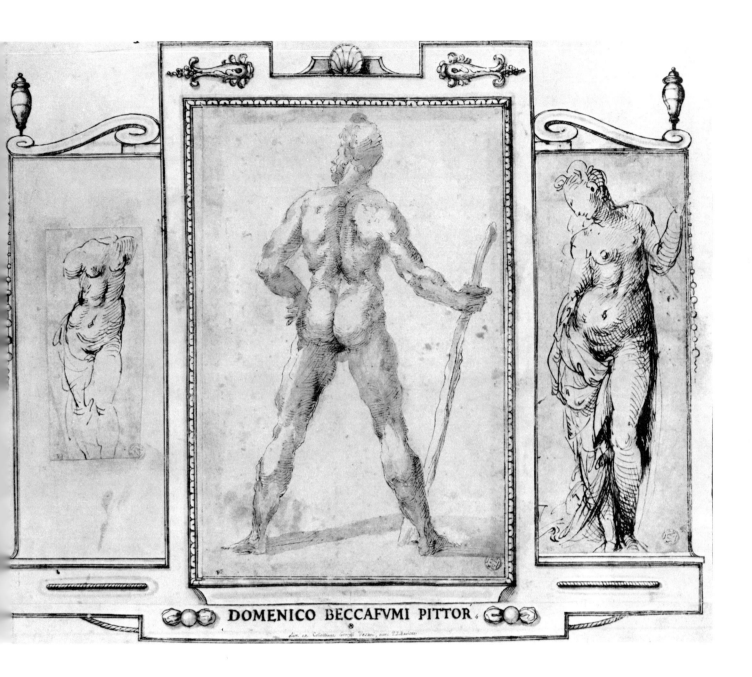

DOMENICO BECCAFVMI PITTOR.

DOMENICO BECCAFUMI

Valdibiena, near Siena, about 1486–Siena 1551

10 *Standing Figure of Moses*

Pen and brown ink, brown wash. 11⁵⁄₁₆ x 7⁷⁄₁₆ in. (28.8 x 18.9 cm.).

Inscribed in pen and brown ink at lower left: *mocarino d siena.*

PROVENANCE: Everhard Jabach (Lugt 2961); Cabinet du Roi from 1671. Inventaire 258.

BIBLIOGRAPHY: J. Judey, *Domenico Beccafumi*, Berlin, 1932, p. 145, no. 166; R. Bacou, *Dessins de maîtres florentins et siennois* (exhibition catalogue), Paris, 1955, no. 61; D. Sanminiatelli, *Domenico Beccafumi*, Milan, 1967, pp. 137, 155, no. 81.

Study for the figure of Moses in the friezelike composition representing Moses Striking the Rock, executed in polychrome marble in the pavement of the Duomo in Siena. The figure of Moses is modeled with strong contrasts of light and shade that were reproduced in the pavement somewhat in the manner of a chiaroscuro print. At the left there is a pen sketch of the kneeling figure that appears behind Moses in the mosaic. Beccafumi received payment in 1525 for the preparatory cartoon of the composition (now in the Siena Pinacoteca; repr. Sanminiatelli, pls. 32a–d).

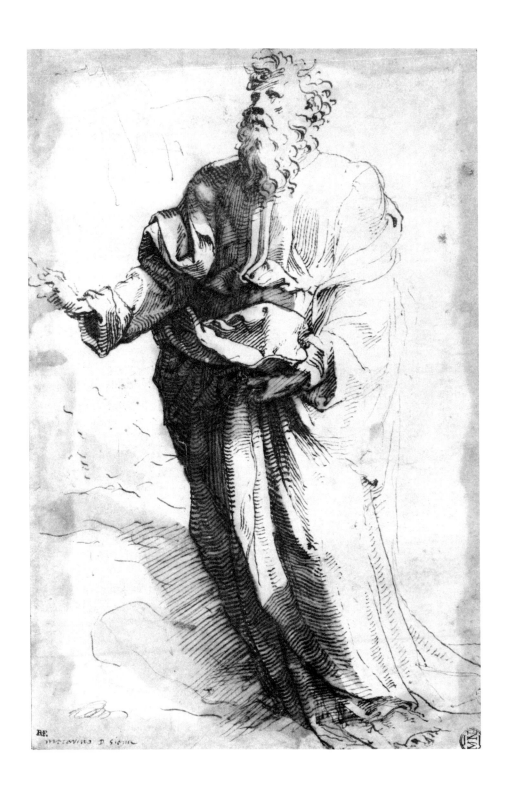

DOMENICO BECCAFUMI

Valdibiena, near Siena, about 1486–Siena 1551

11 *Two Nude Male Figures*

Red chalk. 7⅛ x 10½ in. (18.2 x 26.7 cm.).

Inscribed in pen and brown ink at lower right: *Micharino.*

PROVENANCE: Nicholas Lanier (Lugt 2886); P. H. Lankrink (Lugt 2090); Jonathan Richardson, Senior (Lugt 2184 and 2983); entered the Museum National during the Revolution.
Inventaire 283.

BIBLIOGRAPHY: J. Judey, *Domenico Beccafumi,* Berlin, 1932, p. 146; R. Bacou, *Le XVI⁰ siècle europeén: Dessins du Louvre* (exhibition catalogue), Paris, 1965, no. 85.

These two studies of nudes are comparable, in the lightness of the red chalk line and the subtle indications of light, to some of the drawings for the *St. Michael* in the church of the Carmine and for the *Fall of the Rebel Angels* in the Pinacoteca, Siena, executed in 1524 and 1530 (Sanminiatelli, p. 145, no. 36, and Inv. 10.736). However, these studies cannot with certainty be connected to either of these paintings. Figures in similar positions are found in a number of works by Beccafumi, notably in his mosaic pavement designs for the Siena Duomo, executed between 1519 and 1524, especially in the scene representing the Death of the False Prophets (repr. Sanminiatelli, pl. 18b).

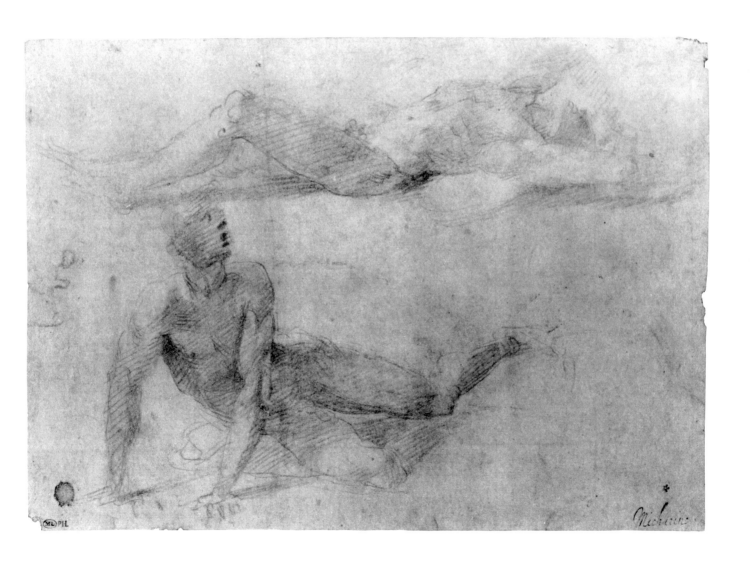

JACOPO BERTOIA

Parma 1544–Parma 1574

12 *The Construction of a Rotunda*

Pen and brown ink, brown wash. Partially squared off in black chalk. 16½ x 11 in. (42.0 x 28.0 cm.). Paper patched at center of right margin and drawing continued in artist's hand.

PROVENANCE: Everhard Jabach (Lugt 2959), with his gold border; Cabinet du Roi from 1671.
Inventaire 10.679.

BIBLIOGRAPHY: Jabach Inventory, I, no. 313 (as Bertoia).

It is interesting to note that this drawing was correctly attributed to Bertoia when it belonged to Jabach and that it is described in the inventory of this celebrated collection at the time of its acquisition by Louis XIV in 1671. Although later classed amongst the anonymous Italian drawings, it was recognized as the work of Bertoia by Philip Pouncey. Konrad Oberhuber suggests that it is a study for one of the compositions the artist painted in the Sala di Ercole in the Farnese Palace at Caprarola. Bertoia died at the age of thirty, but during the short period of his artistic activity he received important commissions from the Farnese family for Caprarola, and for the Palazzo del Giardino in Parma (A. G. Quintavalle, *Il Bertoia*, Parma, 1963, and "Le Bertoia peintre des Farnèse," *L'Oeil*, January, 1964, pp. 2–11). At Caprarola, where he worked from 1569 to 1574, he painted decorations in the Sala della Penitenza, the Sala dei Giudizi, and the Sala del Sogno (K. Oberhuber, "Zu Jacopo Bertoja und Lelio Orsi," *Albertina Studien*, I, 1965, p. 23).

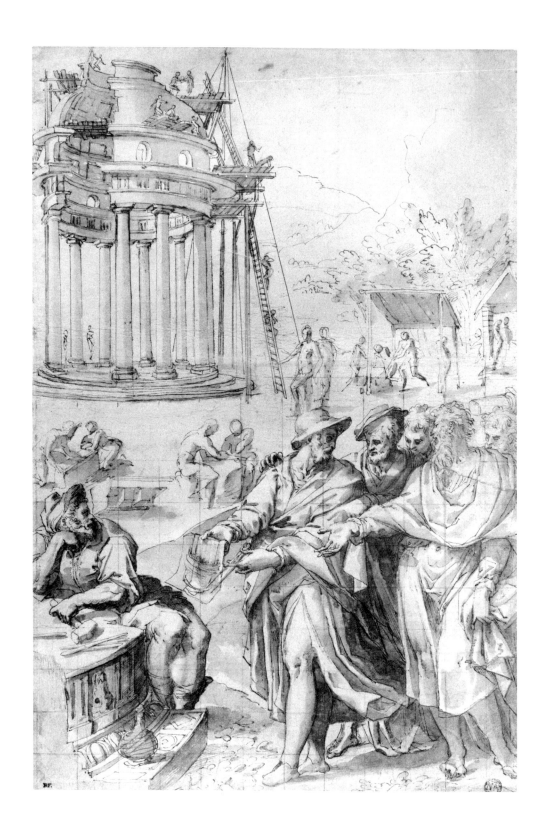

ANGELO DI COSIMO ALLORI, called BRONZINO

Monticelli, near Florence 1503–Florence 1572

13 *Nude Male Figure Lifting a Sack*

Black chalk. Squared off in black chalk.
18¼ x 9³⁄₁₆ in. (46.4 x 23.3 cm.).

PROVENANCE: Everhard Jabach (Lugt 2959);
Cabinet du Roi from 1671.
Inventaire 10.900.

BIBLIOGRAPHY: C. H. Smyth, *Bronzino as
Draughtsman, an Introduction*, New York,
1971, pp. 44–45, fig. 40; J. Cox Rearick,
"Dessins de Bronzino pour la chapelle
d'Eleonora au Palazzo Vecchio," *Revue
de l'Art*, 14, 1971, p. 21; Monbeig-Goguel,
1972, no. 13, repr.

This drawing was classified at the Louvre amongst the anonymous
Italian drawings until it was identified by Craig Hugh Smyth as
Bronzino's study for the man represented in the same position, but
wearing a light drapery, that appears in the left foreground of the
fresco the *Martyrdom of St. Lawrence* in S. Lorenzo, Florence. The
cartoon for this fresco was approved in 1565 by Cosimo de' Medici
and the fresco itself was finished in August 1569 (repr. Venturi, IX,
6, fig. 47). Smyth and Cox Rearick agree on the attribution of this
important drawing to Bronzino; it is characteristic of the late work
of the artist, as is another study for the St. Lawrence fresco pre-
served at the Uffizi (10220 F).

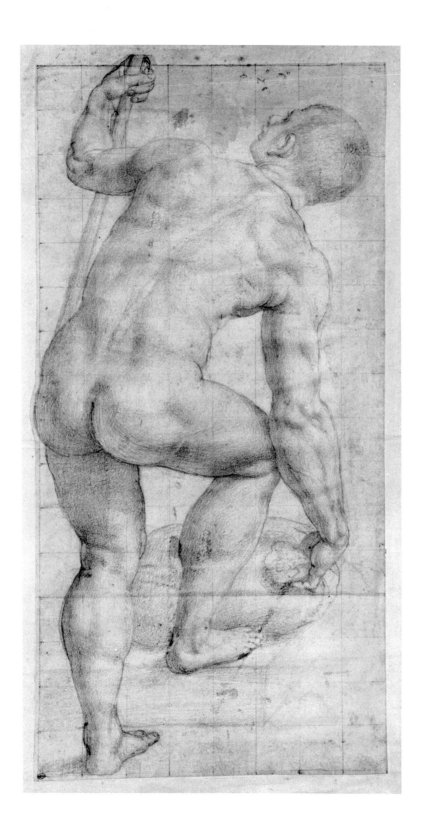

ANTONIO ALLEGRI, called CORREGGIO

Correggio 1489/1494–Correggio 1534

14 *Scene of Baptism with St. Sebastian and St. Julian*

Red chalk. 7⅝ x 6¹¹⁄₁₆ in. (19.4 x 17.0 cm.).

Numbered in pen and brown ink at lower right: *114.*

PROVENANCE: Baron de Thun? (Lugt 2965); entered the Museum National during the Revolution.
Inventaire 10.307.

BIBLIOGRAPHY: P. Pouncey, "An Unknown Early Drawing by Correggio in the Louvre," *Burlington Magazine*, 1951, p. 84, fig. 1; A. E. Popham, *Correggio's Drawings*, London, 1957, pp. 149–150, no. 4, pl. v; R. Bacou and F. Viatte, *Dessins de l'Ecole de Parme* (exhibition catalogue), Paris, 1964, no. 1, pl. I.

In 1951 Philip Pouncey identified this drawing, classed up to then with the anonymous Italian drawings, as a youthful work of Correggio. The subject is mysterious: the youth tied to a column at the left is no doubt St. Sebastian; the Pope baptizing a man kneeling at the center, assisted by two acolytes, could be St. Fabian, whose feast is celebrated on the same day as that of St. Sebastian and who is said to have baptized Philip of Arabia. Pouncey proposed that the man stabbing two figures sleeping in a canopied bed in the right background may be St. Julian the Hospitator murdering his parents. The attribution to Correggio was accepted in 1957 by A. E. Popham, who considered the drawing to be one of the most significant drawings of the artist's early years, similar in style to the probably contemporary studies for the decoration of the Camera di San Paolo in Parma executed in 1518–19.

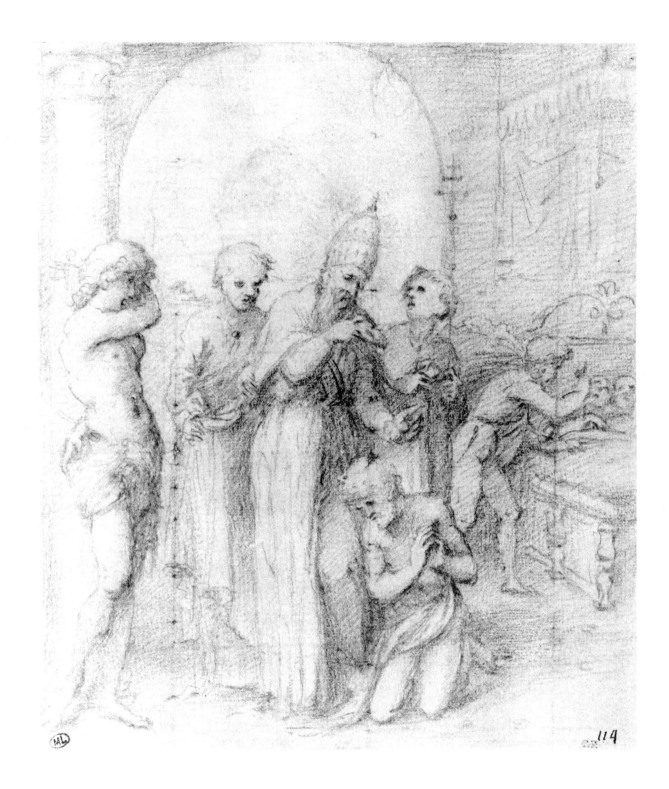

114

ANTONIO ALLEGRI, called CORREGGIO

Correggio 1489/1494–Correggio 1534

15 *Studies of Angels*

Pen and brown ink, brown wash, red chalk. 10⅝ x 7¹⁵⁄₁₆ in. (27.0 x 20.2 cm.).

Inscribed in pen and brown ink at lower left: *Corregio.*

PROVENANCE: P.-J. Mariette (Lugt 1852); his mount with cartouche: ANTONII ALLEGRI COREGIENSIS; Mariette sale, Paris, 1775, part of no. 119; entered the Museum National during the Revolution. Inventaire 5929.

BIBLIOGRAPHY: J. Vergnet-Ruiz, *Correggio* (exhibition catalogue), Paris, 1934, no. 18; A. E. Popham, *Correggio's Drawings*, London, 1957, pp. 154–155, no. 28, pl. XXXIII; R. Bacou and F. Viatte, *Dessins de l'Ecole de Parme* (exhibition catalogue), Paris, 1964, no. 11.

The decorative cycle executed by Correggio in the church of S. Giovanni Evangelista in Parma, for which the artist received payments from 1520 to 1524, constitutes his most important work before the decoration of the cupola of the Parma Duomo, undertaken in 1524. Of the fresco representing the Coronation of the Virgin painted in the choir apse of S. Giovanni Evangelista, only the fragments preserved in the Galleria Nazionale, Parma, remain (repr. Popham, 1957, pl. XXIX); but the composition is known through the copy commissioned from Cesare Aretusi before a modification of the apse in 1587 led to the destruction of Correggio's work (repr. C. Gronau, *Correggio, Klassiker der Kunst*, 1907, p. 53). The exhibited sheet bears studies for the groups of angel musicians in the *Coronation*. The *mise en page*, the liberty of the pen work, and the use of vibrant touches of brown wash to modulate light and shade in this drawing announce the virtuosity of masters of the Baroque age, and beyond, the art of Giovanni Battista Tiepolo. In addition to this sheet, which bears on the verso studies for the frieze in the nave of S. Giovanni Evangelista, the Louvre possesses three further studies related to the *Coronation of the Virgin*: a study for the figure of Christ (Popham, 1957, no. 25, pl. XXX b) and two studies for the Virgin (Popham, 1957, no. 26, pl. XXX a and no. 29, pl. XXXI).

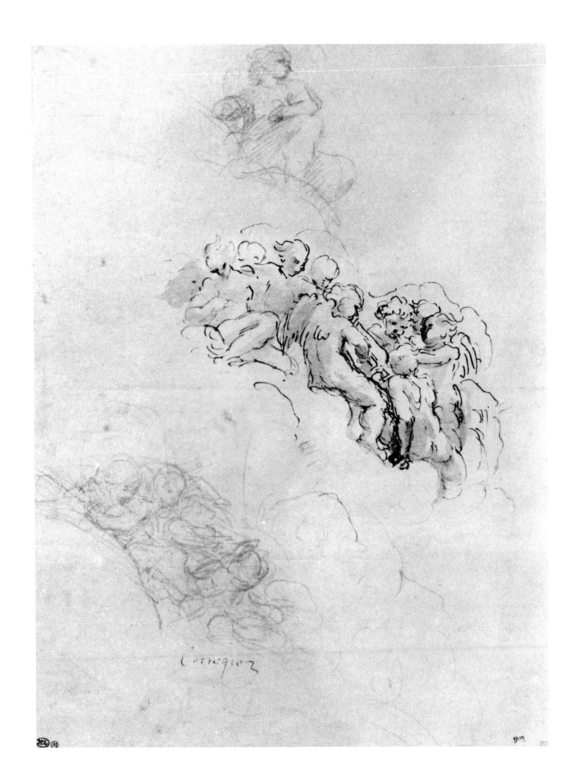

ANTONIO ALLEGRI, called CORREGGIO

Correggio 1489/1494–Correggio 1534

16 *Study of Two Seated Apostles*

Red chalk with traces of white heightening. 8³⁄₁₆ x 10⅞ in. (20.8 x 27.7 cm.).

PROVENANCE: Peter Lely (Lugt 2092); Jonathan Richardson, Senior (Lugt 2183); Arthur Pond; John Barnard (Lugt 1419); entered the Museum National during the Revolution.
Inventaire 5970.

BIBLIOGRAPHY: A. E. Popham, *Correggio's Drawings*, London, 1957, p. 152, no. 14, pl. XVI; R. Bacou and F. Viatte, *Dessins de l'Ecole de Parme* (exhibition catalogue), Paris, 1964, no. 5, pl. II; R. Bacou, *Dessins du Louvre: Ecole italienne,* Paris, 1968, no. 36, repr.

The excellent state of preservation of this drawing underlines the subtle treatment and the brilliance of the orange red chalk; it is a study for the group of two saints in the *Vision of St. John on Patmos,* painted by Correggio in the cupola of S. Giovanni Evangelista in Parma between 1520 and 1524 (repr. Popham, 1957, pl. xv). The figure on the right corresponds almost exactly with that of St. Peter, while the figure on the left, here a youth in a pose inspired by the Adam of Michelangelo in the *Creation of Adam* in the Sistine Chapel, was profoundly changed in the fresco, where St. Paul appears as an old man, seen in left profile. A study for St. Paul in the Albertina in Vienna comes close to the definitive composition (Popham, 1957, no. 11, pl. XI b). The fact that Parmigianino, in a sheet of studies conserved at the Ashmolean Museum (Popham, 1971, no. 330, pl. 8), interpreted motifs that are only to be found in the drawings shown here, or in a similar drawing, testifies to the influence of Correggio on the young artist at the very time, in 1522, when Parmigianino himself was working on his decorations at S. Giovanni Evangelista, and to his knowledge of the drawings of Correggio.

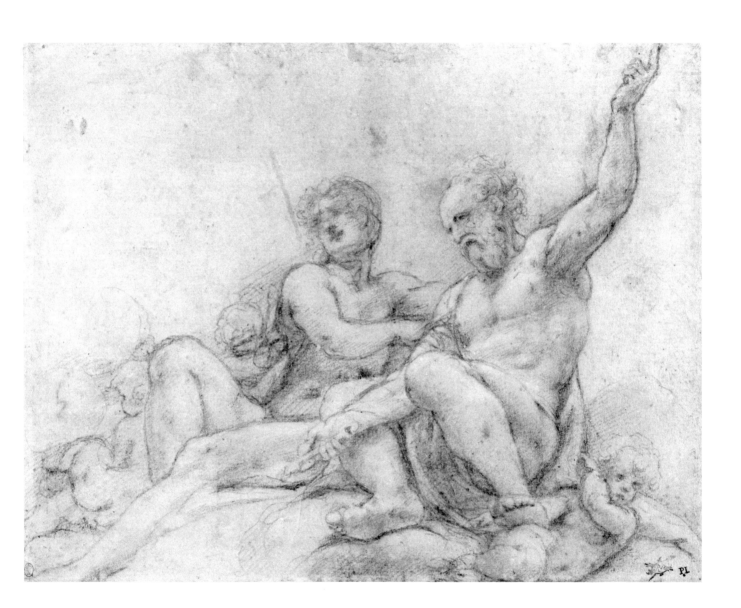

DANIELE RICCIARELLI, called DANIELE DA VOLTERRA

Volterra 1509–Rome 1566

17 *Kneeling Woman with Arms Extended*

Red chalk. 16⅛ x 11¹¹⁄₁₆ in. (41.0 x 29.7 cm.).
Lower right corner replaced.

PROVENANCE: Cabinet du Roi.
Inventaire 1499.

BIBLIOGRAPHY: S. H. Levie, *Album Discipulorum aangeboden aan Professor Dr. J. van Gelder*, Utrecht, 1963, p. 60, fig. 6; B. Davidson, "Daniele da Volterra and the Orsini Chapel, II," *Burlington Magazine* CIX, 1967, p. 561, note 21; J. A. Gere, *Dessins de Taddeo et Federico Zuccaro* (exhibition catalogue), Paris, 1969, no. 6.

S. H. Levie has suggested that this calm and beautiful study may be connected with the lower fresco on the left wall of the Orsini Chapel in SS. Trinità dei Monti, Rome, representing the Emperor Heraclius Placing the True Cross at the Gates of Jerusalem. The decorative scheme of the Orsini Chapel, painted from 1542 by Daniele da Volterra—the first Roman commission of this artist of Tuscan origin—was devoted to the *Legend of the True Cross*, which was represented on the vault and the walls of the chapel. Today almost nothing remains of this decoration with the exception of the celebrated *Deposition*, placed above the altar. This female figure with arms extended is related to a figure that knelt in the foreground of the Heraclius scene, according to Vasari's description of the decoration. However, Bernice Davidson points out that the light in the drawing, which comes from the right, would not correspond to that in the fresco, painted on the left wall, with a light source at the left.

Nonetheless, it is probable that there is a close connection between the Louvre drawing and the decorations in the Orsini Chapel, because of its stylistic similarities with other known studies for this ensemble (M. Hirst, "Daniele da Volterra and the Orsini Chapel, II," *Burlington Magazine*, CIX, 1967, pp. 553–561). Michael Hirst has noted that Daniele's use of red chalk in the 1540s is due to the example of certain drawings by his master, Perino del Vaga, and is echoed in the studies made by Bronzino in Florence in the same years, 1540–50.

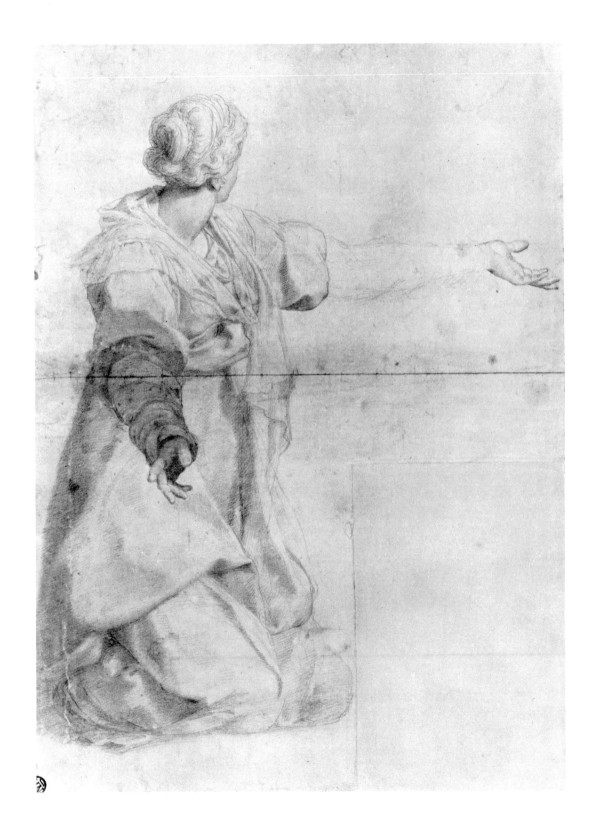

FRANCESCO DI CRISTOFANO, called FRANCIABIGIO

Florence, about 1482–Florence 1525

18 *Head of a Man*

Black chalk and gray wash. 12³⁄₁₆ x 9⅞ in. (31.0 x 25.1 cm.).

PROVENANCE: Everhard Jabach (Lugt 2959 and 2953), with his gold border; Cabinet du Roi from 1671.
Inventaire 1204.

BIBLIOGRAPHY: Jabach Inventory, III, no. 615 (as Peruzzi); Reiset, 1866, no. 212; Berenson, 1961, I, p. 431; II, no. 755; III, fig. 867; R. Bacou, *Dessins de maîtres florentins et siennois* (exhibition catalogue), Paris, 1955, no. 55; R. Bacou, *Le XVI° siècle européen: Dessins du Louvre* (exhibition catalogue), Paris, 1965, no. 80, repr.

The attribution of this portrait to Franciabigio is due to Reiset; Berenson from 1903 accepted the suggestion and proposed that the drawing might be a cartoon for a painting. The old Louvre inventories had given the drawing to Peruzzi (Jabach), then to Andrea del Sarto. The frontality, the truthfulness of the representation, and the placement of the head on the page connect this male head with certain portraits painted by Franciabigio, such as those in the Liechtenstein collection, Vaduz (repr. Venturi, IX, 1, fig. 327) dated 1517 and in Berlin-Dahlem (repr. Venturi, IX, 1, fig. 330), and dated 1522. The broad use of black chalk and of stumping certainly reveals the influence of Andrea del Sarto, a co-pupil of Franciabigio in Albertinelli's studio with whom he collaborated in 1513–15 in the cloister of SS. Annunziata. In 1521, the approximate date of this drawing, Andrea and Franciabigio were both working on the decoration of the Medici villa at Poggio a Cajano.

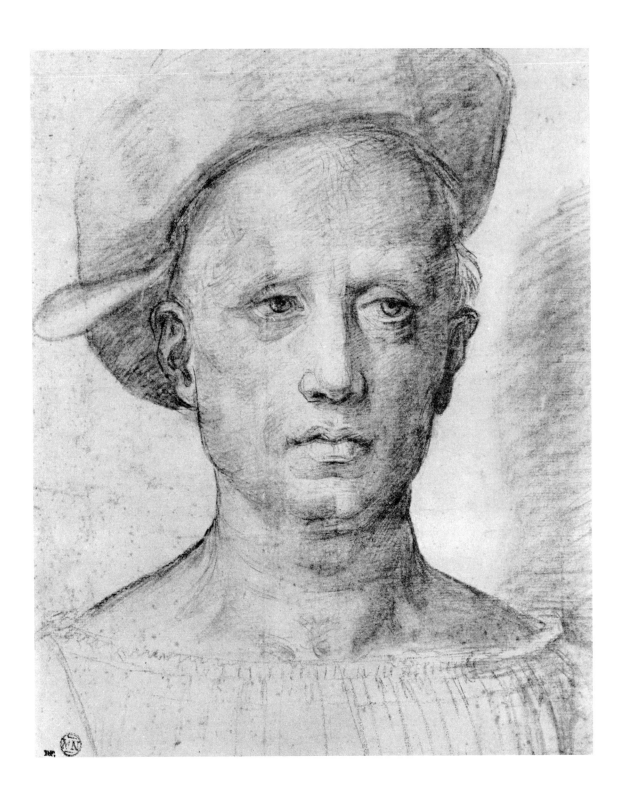

GIOVANNI BATTISTA FRANCO

Venice, about 1498–Venice 1561

19 *The Calling of St. Peter*

Red chalk on beige paper. 11⅝ x 16¹⁵⁄₁₆ in. (29.5 x 43.0 cm.). Upper margin replaced.

PROVENANCE: P.-J. Mariette (Lugt 1852), without his mount; Mariette sale, Paris 1775, part of no. 415; Cabinet du Roi. Inventaire 4926.

This previously unpublished drawing, like No. 20, is difficult to relate to a finished work of Battista Franco. Vasari, in his *Vita di Battista Franco,* makes no mention of a painting or engraving representing the Calling of an Apostle, which must be the subject of this drawing. W. R. Rearick, in his study devoted to Battista Franco and the Grimani Chapel (*Saggi e Memorie di Storia dell'Arte,* 2, Venice, 1959, p. 127, fig. 12), studies and reproduces a similar subject painted in 1560 on the left of the lunette in the Grimani Chapel, S. Francesco della Vigna, Venice. However the scene is different there, and involves only three figures. The friezelike composition favored by Franco in his youthful studies after the antique, executed in Rome in the 1530s, is adopted again here, while the search for a steep perspective testifies to his mastery of spatial problems. It seems plausible to place this drawing around 1552–55, shortly after Franco's return to Venice. The souvenir of Raphael, and especially of the cartoon for *Christ's Charge to Peter,* is apparent in this drawing.

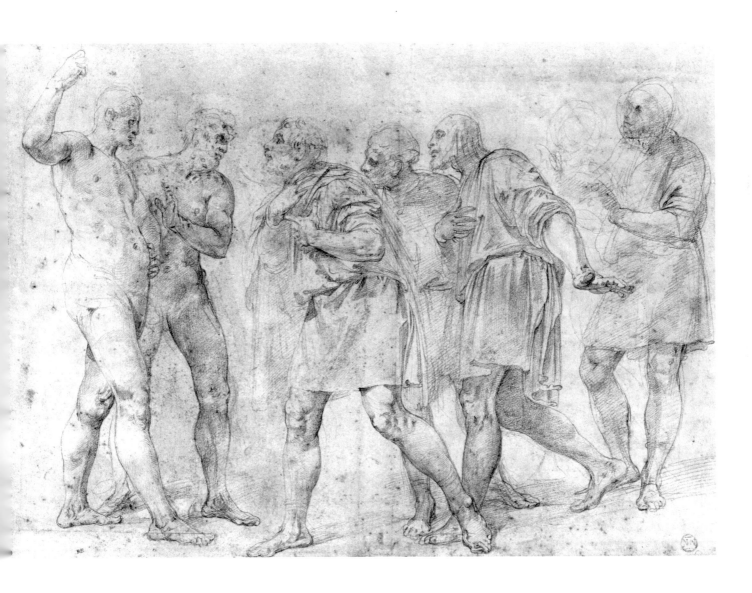

GIOVANNI BATTISTA FRANCO

Venice, about 1498–Venice 1561

20 *Seated Male Figure*

Black chalk, heightened with white, on blue paper. 9½ x 9¹⁵⁄₁₆ in. (24.2 x 25.2 cm.).

Inscribed in pencil at lower left: *Schedon* (?).

PROVENANCE: Entered the Museum National during the Revolution. Inventaire 4972.

Even more than the previous drawing, this powerful study testifies to the influence of contemporary Venetian artists, and particularly of Sebastiano del Piombo, on the art of Battista Franco, whose early formation had been Roman. The figure study should be dated around 1555–61, although it is not possible to establish a direct connection between this figure and Franco's important decorative projects in Venice at the Fondaco dei Tedeschi, the Libreria Vecchia (1556–57), or the Scala d'Oro in the Ducal Palace (1557–61), that were studied by W. R. Rearick in 1959 (*Saggi e Memorie di Storia dell'Arte*, 2, Venice). The drawing is similar in style and technique to one in the British Museum (Pp. 2.123) recently identified by Philip Pouncey as the preparatory study for the figure of Jupiter in the *Conversation on Olympus* in the Museo de Arte, Ponce, Puerto Rico, (Rudolf and Margot Wittkower, "Puerto Rico's Museum," *Apollo*, LXXXV, 1967, p. 184, repr. fig. 4).

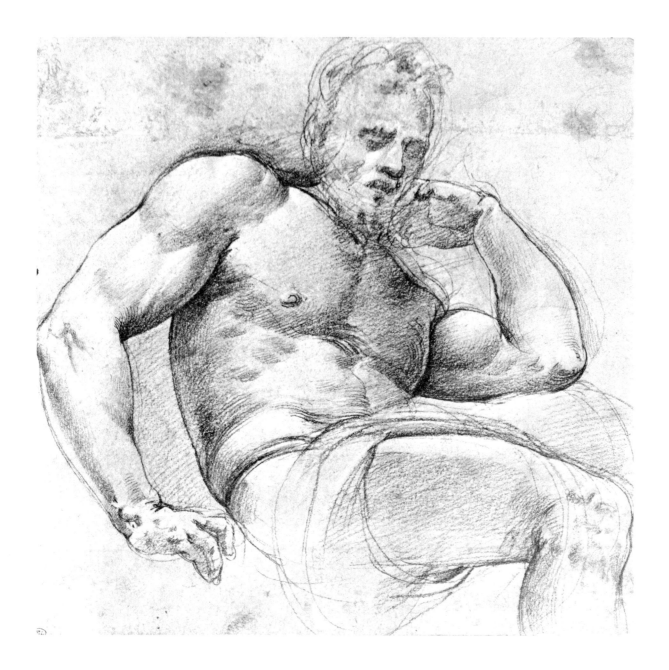

BERNARDINO GATTI, called IL SOJARO

Pavia 1495/1500–Cremona 1576

21 *Standing Draped Male Figure*

Red chalk and red wash heightened with white, black chalk. Squared off in red chalk. 15⁹⁄₁₆ x 7¹⁄₁₆ in. (39.5 x 18.0 cm.). Upper left corner replaced.

PROVENANCE: Peter Lely (Lugt 2092); Jonathan Richardson, Senior (Lugt 2184). Inventaire 6808.

BIBLIOGRAPHY: R. Bacou and F. Viatte, *Dessins de l'Ecole de Parme* (exhibition catalogue), Paris, 1964, no. 37.

A. E. Popham identified this study, formerly classified amongst the anonymous Lombard drawings of the sixteenth century, as a study for the *Multiplication of the Loaves and Fishes* painted by Gatti in 1552 in the refectory of the convent of San Pietro al Po in Cremona (repr. Venturi, IX, 6, fig. 496). Thus the drawing dates from before the period of Gatti's activity in Parma; he did not arrive in that city until 1559, but is nonetheless cited as a pupil of Correggio as early as the end of the sixteenth century. This study is stylistically similar to other drawings by the artist conserved in Chatsworth, the Ashmolean, the Uffizi, and the Ambrosiana. The heavy, deeply shadowed draperies are treated in the same almost geometrical fashion, and the faces are indicated in a very summary way.

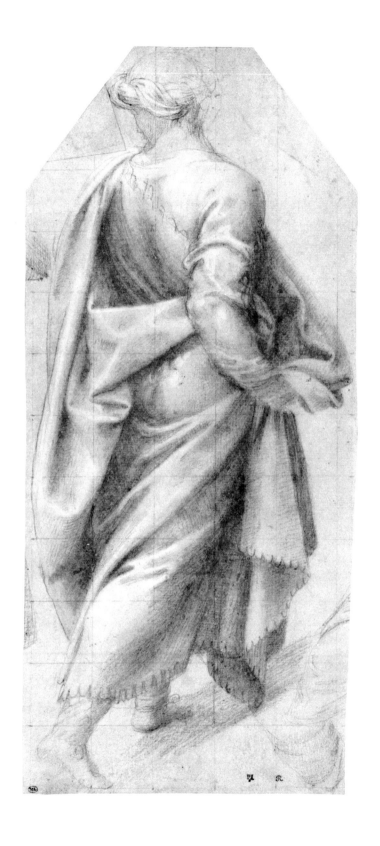

GIULIO ROMANO

Rome 1499–Mantua 1546

22 *Winged Figures of Victory and Barbarian Prisoners: Studies for the Decoration of a Spandrel*

Pen and brown ink, brown wash. Squared off in black chalk. 8¾ x 17¼ in. (22.2 x 43.9 cm.). Lower corners replaced.

PROVENANCE: Everhard Jabach (Lugt 2959), with his gold border; Cabinet du Roi from 1671.
Inventaire 3503.

BIBLIOGRAPHY: Jabach Inventory, III, no. 138 (as Giulio Romano); F. Hartt, "Gonzaga Symbols in the Palazzo del Té," *Journal of the Warburg and Courtauld Institutes*, XIII, 1950, p. 160, pl. 38 b; Hartt, 1958, pp. 100, 300, no. 211, fig. 164.

The frescoes decorating the garden façade of the Palazzo del Te in Mantua, executed in 1523 by Fermo da Caravaggio, are no longer visible. On the basis of documentary evidence, Hartt (1958, no. 155, pp. 321–322) has proposed the identification of this finished squared drawing as the *modello* for the decoration of one of the spandrels of this façade, and specifically for the last spandrel on the right of the left wing of the façade. In the Ecole des Beaux-Arts, Paris, is preserved a study for the left section of another spandrel, with figures of Victory and a prisoner seated on the ground (ibid., no. 212, fig. 165). A third drawing with two standing barbarians, from the Ellesmere collection, has been connected with this decorative scheme (ibid., no. 213; Ellesmere sale, *Drawings by Giulio Romano*, London, Sotheby's, December 5, 1972, no. 46, repr.).

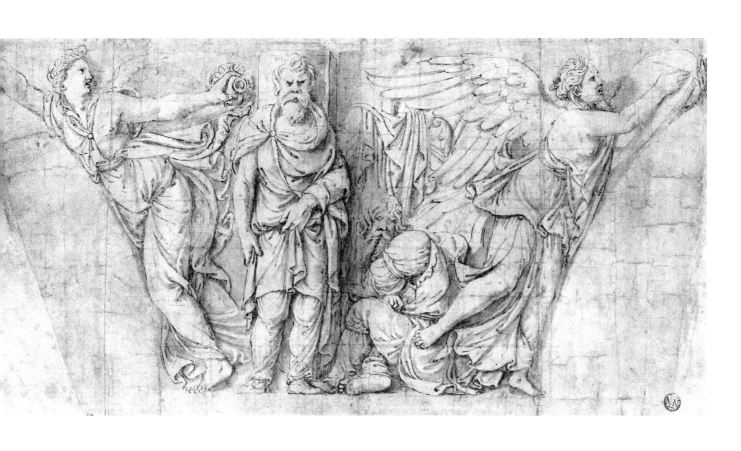

GIULIO ROMANO

Rome 1499–Mantua 1546

23 *River Fishermen Pulling in Nets*

Pen and brown ink, brown wash.
10⁵⁄₁₆ x 16¹³⁄₁₆ in. (26.3 x 42.8 cm.).

Numbered in pen and brown ink at center of lower margin: *69*.

PROVENANCE: Everhard Jabach; Pierre Crozat; Crozat sale, Paris, 1741, part of no. 141; P.-J. Mariette; Mariette sale, Paris, 1775, no. 598; Cabinet du Roi. Inventaire 3561.

BIBLIOGRAPHY: Recueil Crozat, 1729, pl. 65; Mariette, *Abecedario*, IV, p. 166; Hartt, 1958, no. 150, fig. 215; R. Bacou, *P.-J. Mariette* (exhibition catalogue), Paris, 1967, no. 67; F. Viatte, *Il Paesaggio nel disegno del cinquecento europeo* (exhibition catalogue), Rome, 1972–1973, no. 47, repr.

Modello for one of the sixteen medallions that decorate the Sala dei Venti in the Palazzo del Te, executed at the end of 1527 and the beginning of 1528 (Hartt, 1958, p. 115); Giulio's design was painted in reverse by Girolamo da Pontremoli (ibid., fig. 200). The direct realism of the scene is underlined by a clever composition based on a play of curved lines and oblique angles, while the use of broad areas of brown wash to indicate planes and spatial recession looks forward to the investigations of landscape artists of the seventeenth century. The drawing belonged to some of the most celebrated French collectors of the *Ancien Régime*: Everhard Jabach, Pierre Crozat, who had it engraved for his *Recueil*, and Pierre-Jean Mariette, at whose posthumous sale it was acquired for the Cabinet du Roi. It is interesting to note that in 1671 Jabach sold, as an original, a copy of this drawing to Louis XIV (Jabach Inventory, III, no. 155; Inv. 3760).

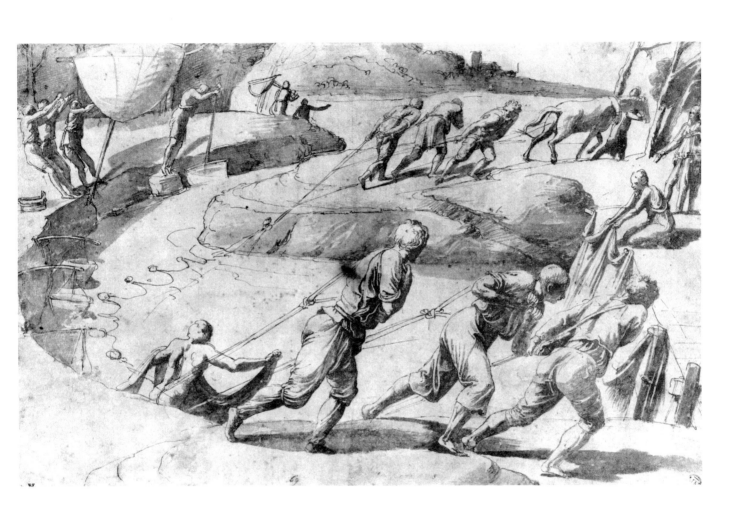

GIULIO ROMANO

Rome 1499–Mantua 1546

24 *Psyche Receiving the Vase Containing Proserpina's Beauty*

Pen and brown ink, brown wash.
7¹³/₁₆ x 14⁹/₁₆ in. (19.8 x 37.0 cm.).

Inscribed in pen and brown ink at lower right:
Jul. Ro.

PROVENANCE: Everhard Jabach (Lugt 2959),
with his gold border.
Inventaire 3492.

BIBLIOGRAPHY: Jabach Inventory, III, no. 173
(as Giulio Romano); Hartt, 1958, no. 171,
fig. 270; Pouncey-Gere, 1962, under no. 74.

Modello for one of the twelve lunettes in the Sala di Psiche in the Palazzo del Te, Mantua (repr. Hartt, 1958, fig. 252). In the decoration of this principal room in the north wing, executed in 1528 with the assistance of Benedetto Pagni and Rinaldo (ibid., p. 127), Giulio took up and amplified the Psyche legend, drawn from the *Golden Ass* of Apuleius, which had been represented in frescoes at the Farnesina in Rome, under the direction of Raphael. The scene, admirably composed to fit the semicircular space, represents Psyche before Proserpina and Pluto, receiving from Proserpina the vase of Beauty, surrounded by Cerberus and underworld divinities. A sketch for the composition, in pen alone, is in the British Museum (ibid., no. 170, fig. 269; Pouncey-Gere, 1962, no. 74, pl. 67); a second drawing close to the *modello* exhibited here was in the Ellesmere collection (*Drawings by Giulio Romano*, London, Sotheby's, December 5, 1972, no. 31, repr.). Hartt did not list this latter drawing, and P. A. Tomory considered it a copy after the fresco (*The Ellesmere Collection*, 1954, no. 99).

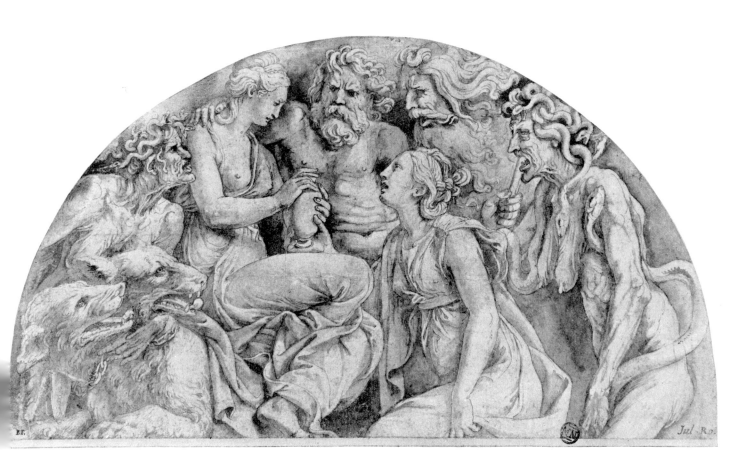

GIULIO ROMANO

Rome 1499–Mantua 1546

25 *Head of a Bearded Man Looking Upward*

Black chalk, heightened with white, on blue
 paper. 12¹⁄₁₆ x 13³⁄₁₆ in. (30.6 x 33.5 cm.).
 The sheet composed of separate pieces of
 paper glued together.

PROVENANCE: John Barnard (Lugt 1419);
 entered the Museum National during the
 Revolution.
 Inventaire 3570.

BIBLIOGRAPHY: Hartt, 1958, no. 243, fig. 432.

According to Vasari, frescoes for the Duomo in Verona were commissioned from Giulio Romano by Gianmatteo Giberti, Bishop of Verona from 1524 (Hartt, 1958, p. 203); they were executed after Giulio's designs by Francesco Torbido in 1534 (repr. ibid., figs. 425–430). The subject treated in the half-dome of the apse is the Assumption of the Virgin seen before a background of simulated coffering; the scene is witnessed by apostles who stand behind a balustrade in attitudes of astonishment and fright that recall the decoration of the Sala dei Giganti in the Palazzo del Te finished by Giulio at the time he executed the drawings for the Verona Duomo. A highly finished *modello* for the Virgin surrounded by angels is preserved in the Teyler Museum, Haarlem (ibid., no. 370, fig. 539). Hartt suggested that the present drawing is a study for the head of one of the apostles in the *Assumption*, probably the second on the left; a more specific identification is difficult because of Torbido's inability to translate into paint the monumentality and the expressive beauty of such a drawing as this.

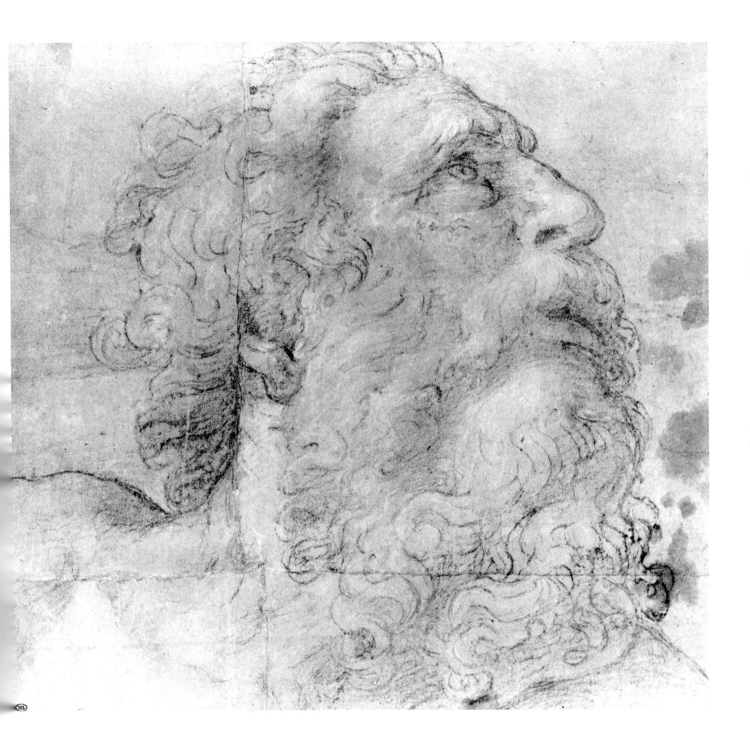

GIULIO ROMANO

Rome 1499–Mantua 1546

26 *Project for the Tomb of a Cardinal*

Pen and brown ink, brown wash, heightened
with white, on brownish paper. Squared off
in black chalk. 10⅟₁₆ x 15⅞ in.
(25.6 x 40.4 cm.).

PROVENANCE: Everhard Jabach (Lugt 2959),
with his gold border; Cabinet du Roi from
1671.
Inventaire 3577.

BIBLIOGRAPHY: Jabach Inventory, III, no. 240
(as Giulio Romano); Hartt, 1958, no. 248,
fig. 438.

The style of this *modello* for a funerary monument, as Hartt points
out (1958, pp. 206–207), is closely related to Giulio's drawings for
the decoration of the Verona Duomo, executed by Francesco Tor-
bido in 1534 (see No. 25). The two angels carrying torches and
holding a bishop's miter and a cardinal's hat are close to the angels
crowning the Virgin in the preparatory drawing in the Louvre for
one of the frescoes in the Duomo (Hartt, 1958, no. 243, fig. 430).
A pectoral cross, almost identical to that lifted by the two little
angels at the center of the present drawing, appears in the frieze
of the apse in the Verona Duomo (ibid., fig. 429). Hartt suggested
that this drawing is the unexecuted project for the tomb of the
Bishop of Verona, Gianmatteo Giberti, who commissioned the
Duomo decorations from Giulio.

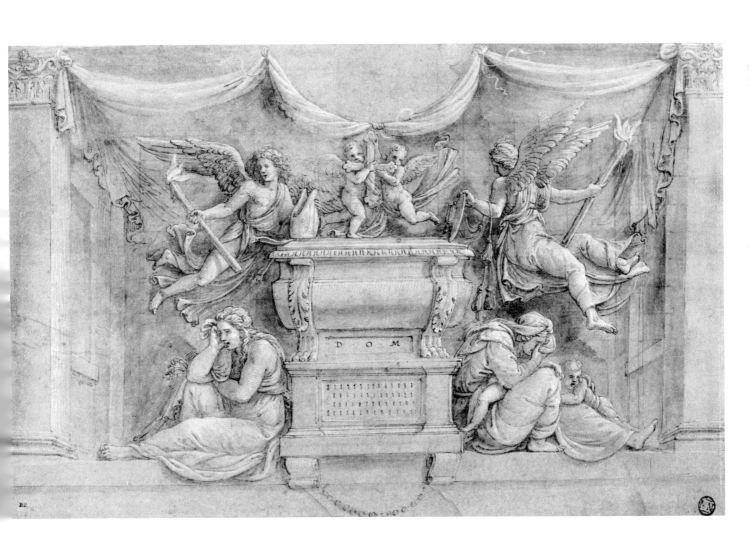

GIROLAMO MAZZOLA-BEDOLI

Viadana, about 1500 (?)–Parma 1569

27 *Allegory of the Immaculate Conception*

Red chalk, heightened with white, on beige paper. 12³⁄₁₆ x 8¼ in. (31.0 x 21.0 cm.).

PROVENANCE: Everhard Jabach (Lugt 2959 and 2953); Cabinet du Roi from 1671. Inventaire 6431.

BIBLIOGRAPHY: Jabach Inventory, II, no. 274 (as Parmigianino); R. Bacou and F. Viatte, *Dessins de l'Ecole de Parme* (exhibition catalogue), Paris, 1964, no. 97, pl. XXIII (with previous bibliography); A. E. Popham, "The Drawings of Girolamo Bedoli," *Master Drawings*, II, 3, 1964, pp. 248–249, 264, no. 17, pl. 2.

Study for the *Allegory of the Immaculate Conception* painted between 1533 and 1538 by Mazzola-Bedoli for the Oratorio della Concezione in Parma, and now in the Galleria Nazionale in that city (repr. Venturi, IX, 2, fig. 577). This study differs in many ways from the finished work, notably in that Joachim Being Driven from the Temple is represented in the lower part of the painting. Popham pointed out that the iconography of this painting was the subject of much discussion between the artist and his patrons, the Company of the Immaculate Conception. The delicate red chalk cross-hatching in the drawing is characteristic of Bedoli; this is one of his earliest drawings distinguishable from, though strongly influenced by, the work of his master, Parmigianino.

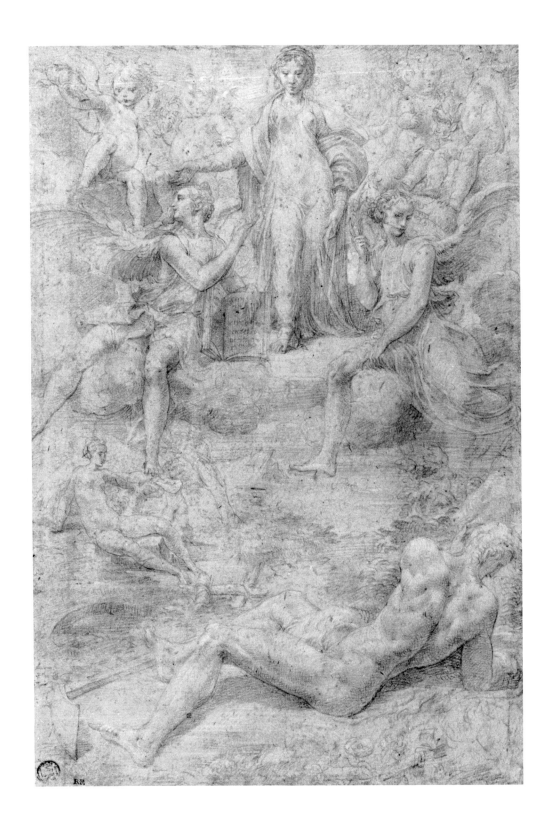

MICHELANGELO BUONARROTI

Caprese 1475–Rome 1564

28 *Standing Male Nude*

Pen and brown ink. 14¾ x 7¹¹⁄₁₆ in.
(37.5 x 19.5 cm.).

PROVENANCE: Everhard Jabach (Lugt 2961);
Cabinet du Roi from 1671.
Inventaire 689.

BIBLIOGRAPHY: Thode, 1913, no. 478; Wilde,
1953, p. 4; Tolnay, *Michelangelo*, IV, 1954,
p. 147, no. 41a; Dussler, 1959, no. 646;
Berenson, 1961, I, pp. 297–323; II, no. 1589;
III, fig. 596; P. Barocchi, *Michelangelo*
(exhibition catalogue), Florence, 1964, no.
7; M. Sérullaz, *Le XVIᵉ siècle européen:
Dessins du Louvre* (exhibition catalogue),
Paris, 1965, no. 33, pl. x.

A remarkable study of a figure in movement, accepted as an original work by Thode, Berenson, Wilde, and Barocchi. The firm plasticity of the modeling and the characteristic pen work of this drawing are related to studies executed by Michelangelo between 1500 and 1505: in particular, as Wilde remarked (1953, p. 4), the *Head of a Satyr* in the British Museum (Berenson, 1961, no. 1520; Wilde, no. 2, pl. II), and the *Standing Nude* in the Louvre (Inv. RF 1068 verso; Berenson, no. 1590 recto, fig. 542). The expressive freedom of the corrections in the right arm and the left leg are comparable to those in a sketch in the Louvre representing Mercury-Apollo (Inv. 688; Berenson, no. 1588). The rapid, cursive sketch of a Virgin Seated, on the verso of the present sheet (Berenson, fig. 621; Dussler, no. 354, pl. 32), seems to confirm this dating; the drawing on the verso is accepted by Goldscheider and Tolnay who do not accept the recto as the work of Michelangelo (Goldscheider, 1951, no. 55, repr.; Tolnay, *Michelangelo*, V, 1960, no. 140, fig. 99).

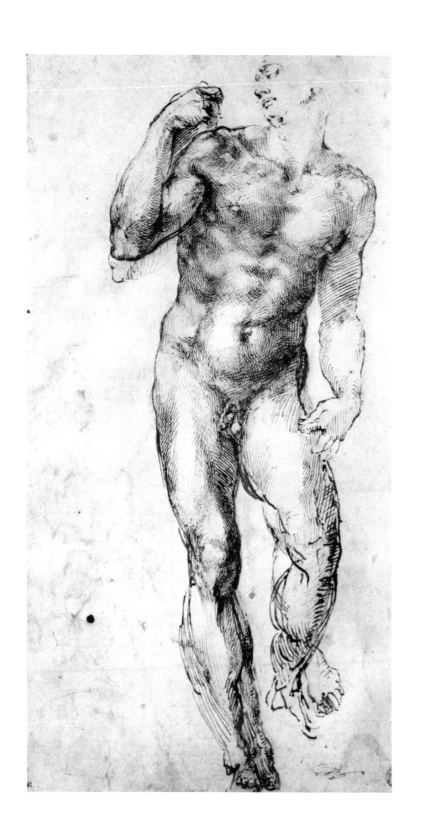

MICHELANGELO BUONARROTI

Caprese 1475–Rome 1564

29 *Head of a Satyr*

Pen and brown ink over a design in red chalk.
10⅞ x 8⁵⁄₁₆ in. (27.6 x 21.1 cm.).

PROVENANCE: P.-J. Mariette (Lugt 1852);
Mariette sale, Paris, 1775, part of no. 236;
Cabinet du Roi.
Inventaire 684.

BIBLIOGRAPHY: Mariette, *Abecedario*, I, pp.
226–227; Reiset, 1866, no. 109; Thode, I,
1908, p. 63; III, 1913, no. 460; B. Berenson,
"Andrea di Michelangiolo e Antonio Mini,"
L'Arte, 1935, pp. 269–270, repr. p. 267; R.
Wittkower, "Physiognomical experiments
by Michelangelo and his pupils," *Journal
of the Warburg and Courtauld Institutes*,
I, 1937, p. 183, fig. 23 b.; Goldscheider,
1951, no. 199, fig. 199; Dussler, 1959, no.
644; Berenson, 1961, I, pp. 374–375; II, no.
1728; III, fig. 738; M. Sérullaz, *Le XVIᵉ
siècle européen: Dessins du Louvre* (exhibi-
tion catalogue), Paris, 1965, no. 35, pl. x.

This drawing was long regarded as one of the masterworks of
Michelangelo's youth; Mariette wrote of it, "I possess a very beau-
tiful and most curious drawing by Michelangelo representing the
head of a faun or satyr, seen in profile and nearly life-size, drawn
in pen with all the art and science of which he was capable, on top
of a red chalk head of a woman which had been previously drawn
on the same sheet by some poor ignorant draughtsman . . ."
(*Abecedario*, I, pp. 226–227). With the exception of Thode, Brinck-
mann, Delacre, and Panofsky, who considered the drawing to be
an original by Michelangelo, most modern critics have been severe
on this drawing. The satyr's head is a remarkable piece of virtu-
osity, and if it is the work of a disciple, he must have been one
who had a remarkable ability to assimilate the master's style
of 1500–05. Berenson attributed the satyr's head to Andrea di
Michelangelo, while Goldscheider proposed the name of Battista
Franco; the red chalk underdrawing of the head of a woman and
the sketches on the verso (Dussler, pl. 224) are generally attributed
to Antonio Mini.

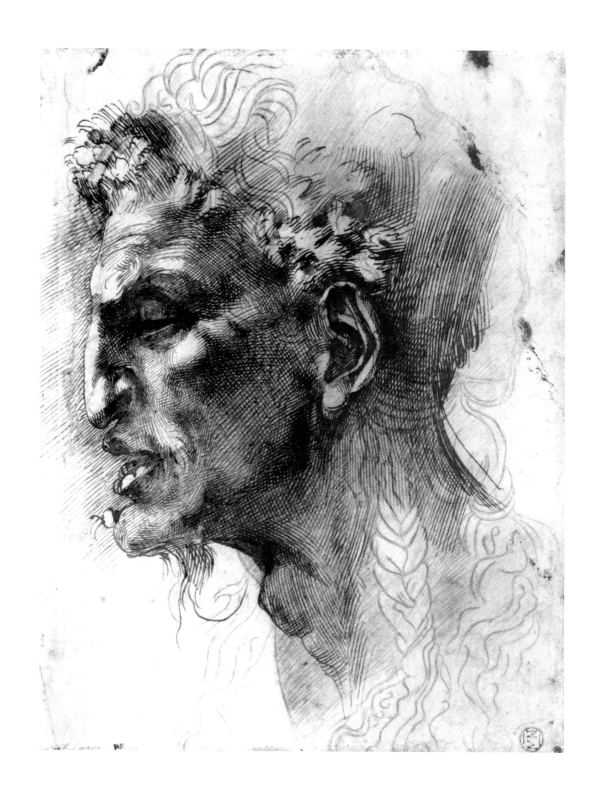

MICHELANGELO BUONARROTI

Caprese 1475–Rome 1564

30 *Seated Woman Holding a Child*

Red chalk. Framing lines in red brown chalk.
11³⁄₈ x 8³⁄₁₆ in. (29.0 x 20.9 cm.).

Inscribed in brush and red brown wash at lower
right: *MichaelAnge. F.*

PROVENANCE: Cabinet du Roi.
Inventaire 692.

BIBLIOGRAPHY: Reiset, 1866, no. 113; Thode,
1908, I, p. 271; II, pp. 410, 433; Dussler,
1959, p. 290, no. 649 (with previous
bibliography); Berenson, 1961, I, pp. 359–
360; II, no. 2495; III, fig. 703; Charles de
Tolnay, "Le Madonne di Michelangelo,"
*Mitteilungen des Kunsthistorischen
Instituts in Florenz,* 13, 1968, p. 356, note
37, p. 360, fig. 37.

The position of the seated Virgin, drawn here in light red chalk, is close to that of the Libyan Sibyl painted by Michelangelo on the vault of the Sistine Chapel. The *contrapposto* twist of the body and the tension are similar, but the gesture of the arms differs and the Sibyl's book is replaced here by the Christ Child, held up by His Mother in a gesture of presentation or offering. In the background is indicated a female figure, perhaps a recollection of the *Virgin and St. Anne* shown by Leonardo in Florence in 1501 which had already influenced his *Madonna Doni* (Florence, Uffizi, about 1503–04). The style of the drawing would suggest a date in Michelangelo's career around 1530.

The attribution of this fine drawing to Michelangelo has been the subject of much discussion. Thode accepted it as an original, but wrongly dated it to the period of the Sistine Chapel. Berenson is responsible for the attribution to Sebastiano del Piombo of a group of red chalk drawings representing the Virgin and Child, including the drawing shown here and the two further sheets in the Louvre (Inv. 691 and 703; Berenson, 1961, II, nos. 2494, 2496). His opinion has been accepted by many other critics including Dussler, but not by Tolnay, who has recently made an interesting study of Michelangelo's different interpretations of the theme of the Virgin and Child.

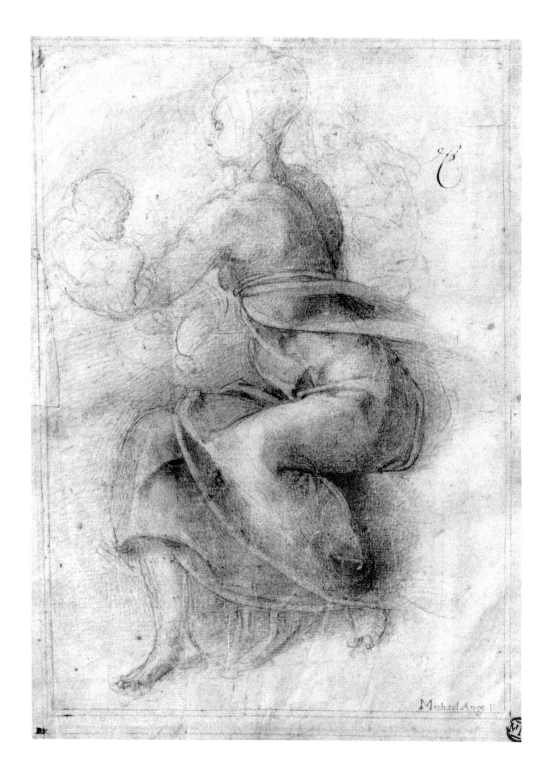

Michael Ange.l

MICHELANGELO BUONARROTI

Caprese 1475–Rome 1564

31 *The Dead Christ*

Black chalk. 10 x 12½ in. (25.4 x 31.8 cm.).

PROVENANCE: M. Buonarroti; J.-B. Wicar;
Thomas Lawrence (Lugt 2445); King
William II of Holland; sale, The Hague,
12–20 August, 1850, no. 118.
Inventaire 716.

BIBLIOGRAPHY: Reiset, 1866, no. 125; P.
d'Achiardi, *Sebastiano del Piombo*, Rome,
1908, p. 280; C. Justi, *Michelangelo, Neue
Beiträge*, II, Berlin, 1909, p. 156; E. Panof-
sky, "Die Pietà von Ubeda. Ein Kleiner
Beitrag zur Lösung der Sebastiano Frage,"
Festschrift für Julius von Schlosser,
Vienna, 1927, pp. 150–161; Tolnay, *Michel-
angelo*, III, 1948, p. 21; Wilde, 1953, pp.
95, 104, under nos. 58, 64; Dussler, 1959,
p. 294, no. 664; Tolnay, *Michelangelo*, V,
1960, p. 180, no. 168, pl. 120 (with previous
bibliography); Berenson, 1961, I, p. 343;
II, no. 1586; III, fig. 680; Pouncey-Gere,
1962, p. 164, under no. 276; E. Borea,
"Grazia e furia in Marco Pino," *Paragone*,
XIII, 1962, p. 44, no. 151; P. Barocchi,
*Michelangelo e la sua scuola, I Disegni di
Casa Buonarroti e degli Uffizi*, Florence,
1962, pp. 179–180, under no. 143.

This beautiful study for the Christ in a Pietà, perhaps drawn from
life, is stylistically analogous to Michelangelo's chalk studies
of religious themes that are contemporary with the fresco of the
Last Judgement (1536–41). It may be compared with the *Lamen-
tation on the Dead Christ* in the British Museum (Wilde, 1953, 64
recto, pl. CI) and the *Christ Supported by Nicodemus* in the Alber-
tina (Berenson, 1961, no. 2503, fig. 686). Charles de Tolnay has
noted that the high finish of the drawing and the modeling in light
and shade of the torso evoke the drawings executed by Michel-
angelo at the same period for Tommaso de' Cavalieri.

Nonetheless, the authorship of the drawing and its place in the
chronology of Michelangelo's work have been the subject of con-
troversy, arising from the difficulty of distinguishing the style of
the master from that of his closest pupils and assistants, such as
Sebastiano del Piombo. Panofsky, following the earlier suggestions
of Justi and d'Achiardi, attributed this drawing to Sebastiano,
pointing out its connection with the *Pietà* in S. Salvador in Ubeda,
in southern Spain, painted between 1534 and 1539 for Don Fer-
rante Gonzaga (repr. Berenson, 1961, III, fig. 681).

In 1903 Berenson attributed the drawing to Michelangelo him-
self and convincingly suggested that it was sent by Michelangelo
to Sebastiano, who utilized this representation of the Dead Christ
for the Ubeda *Pietà*. This hypothesis is accepted by most contem-
porary critics.

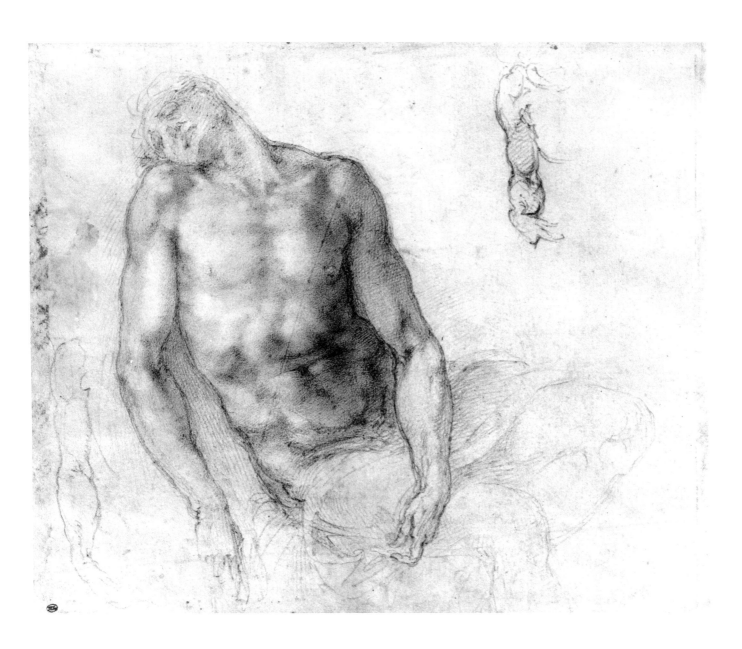

MICHELANGELO BUONARROTI

Caprese 1475–Rome 1564

32 The Crucified Christ between the Virgin and St. John

Black chalk, heightened with white, over brown wash. 17 x 11⅜ in. (43.2 x 29.0 cm.).

PROVENANCE: Everhard Jabach (Lugt 2959); Cabinet du Roi from 1671. Inventaire 700.

BIBLIOGRAPHY: Reiset, 1866, no. 120; Thode, III, 1913, no. 471; Popham-Wilde, 1949, p. 260; Goldscheider, 1951, pl. 13; Wilde, 1953, pp. 120–121; Dussler, 1959, no. 211, pl. 140; Tolnay, *Michelangelo*, V, 1960, no. 249, pl. 224; Berenson, 1961, I, p. 342; II, no. 1583; P. Barocchi, *Disegni di Michelangelo*, Milan, 1964, pl. 68.

A masterwork of the highest quality, belonging to a group of studies by Michelangelo devoted to the theme of the Crucifixion with the Virgin and St. John preserved in the British Museum (Berenson, 1961, no. 1529, fig. 669, and no. 1530, fig. 672; Wilde, 1953, no. 81, pl. CXXIV, and no. 82, pl. CXXV), at Windsor (Berenson, 1961, no. 1621, fig. 668, and no. 1622; Popham-Wilde, no. 437, pl. 31, and no. 436, pl. 32), and at the Ashmolean Museum, Oxford (Berenson, 1961, no. 1574, fig. 670; Parker, no. 343, pl. XCIII). The Louvre possesses two fragments of another version of this scene (Inv. 698, Berenson, 1961, no. 1582, fig. 667; Inv. 720, Berenson, 1961, no. 1595) and a study for the single figure of Christ (Inv. 842, Berenson, 1961, no. 1498a; Tolnay, V, no. 248, pl. 222).

The monumentality of these drawings and their spiritual intensity place them late in Michelangelo's career. Under the influence of his friend the poetess Vittoria Colonna, Michelangelo's religious feeling grew deeper and more intense. These sentiments are expressed in a *Crucified Christ* that the artist gave to his friend, which Johannes Wilde identified as a drawing in the British Museum (1953, no. 67, pl. CIII). However, the series of studies of the *Crucifixion* is generally dated around 1550–57, after Vittoria Colonna's death in 1547.

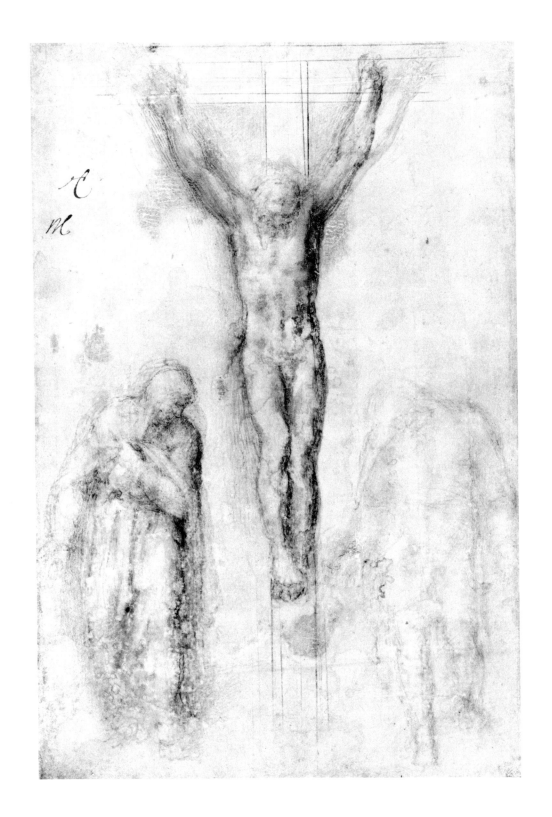

GIROLAMO MUZIANO

Acquafredda near Brescia 1532–Rome 1592

33 *The Stigmatization of St. Francis*

Red chalk. 15¹⁵⁄₁₆ x 12⅜ in. (40.5 x 31.5 cm.).

PROVENANCE: Giorgio Vasari, his mount with cartouche: GIROLAMO BRESCIANO; Everhard Jabach (Lugt 2959), with his gold border; Cabinet du Roi from 1671. Inventaire 5107.

BIBLIOGRAPHY: Jabach Inventory, I, no. 447 (as Muziano); O. Kurz, "Giorgio Vasari's *Libro de' Disegni*," *Old Master Drawings*, XII, December, 1937, p. 40; C. Monbeig-Goguel, *Giorgio Vasari* (exhibition catalogue), Paris, 1965, no. 81.

This highly finished drawing is directly connected with the painting of the same subject in the Chiesa dei Cappuccini in Rome (Ugo di Como, *Girolamo Muziano*, Bergamo, 1930, pp. 134–135, repr. p. 136), an important work mentioned in 1584 by Raffaello Borghini. The landscape background, into which the two monks are so well integrated, plays an essential role in Muziano's art; in the painting St. Francis and his companion are represented in the same positions, but the grotto opens in the background onto a broad horizon.

The decoration of the old mount of the drawing seems to be from the hand of Giorgio Vasari, and if, as seems probable, the sheet was part of Vasari's celebrated *Libro de' Disegni*, Muziano's drawing must date from before Vasari's death in 1574. Two other drawings by Muziano in the Louvre very probably belonged to Vasari (Inv. 5094 and 5095).

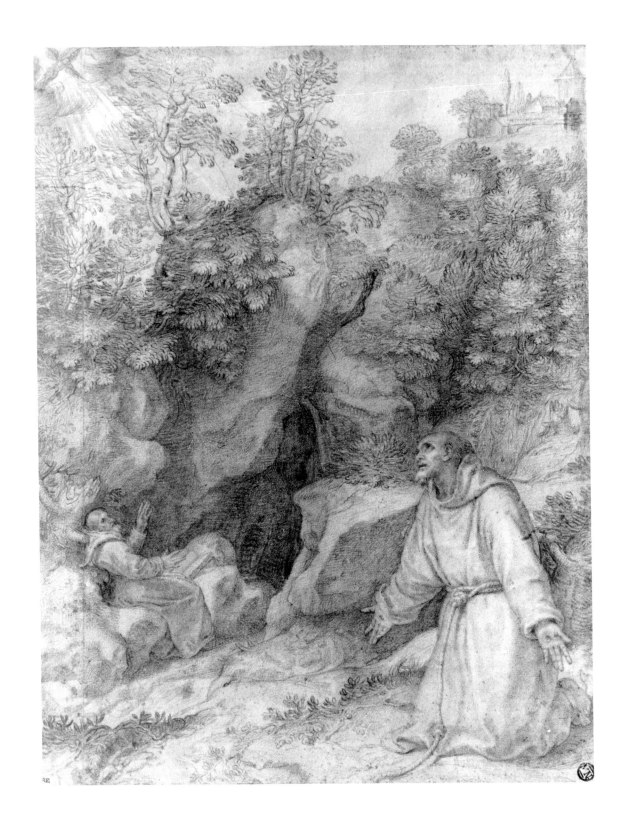

GIROLAMO MUZIANO

Acquafredda near Brescia 1532–Rome 1592

34 *Standing Figure of a King*

Black chalk, heightened with white, on blue
 paper. Squared off in red chalk.
 15¾ x 9¼ in. (40.0 x 23.5 cm.).

PROVENANCE: Everhard Jabach (Lugt 2959);
 Cabinet du Roi from 1671.
 Inventaire 10.850.

This drawing was classified as anonymous Italian until Philip Pouncey suggested that it was the work of Muziano. Muziano's Venetian training is apparent in the technique of the drawing—black chalk heightened with white on blue paper—and by the amplitude of this draped figure of a king holding a globe and a sword, studied and squared off for a still-unidentified painted composition. The way in which the face is drawn is characteristic of Muziano.

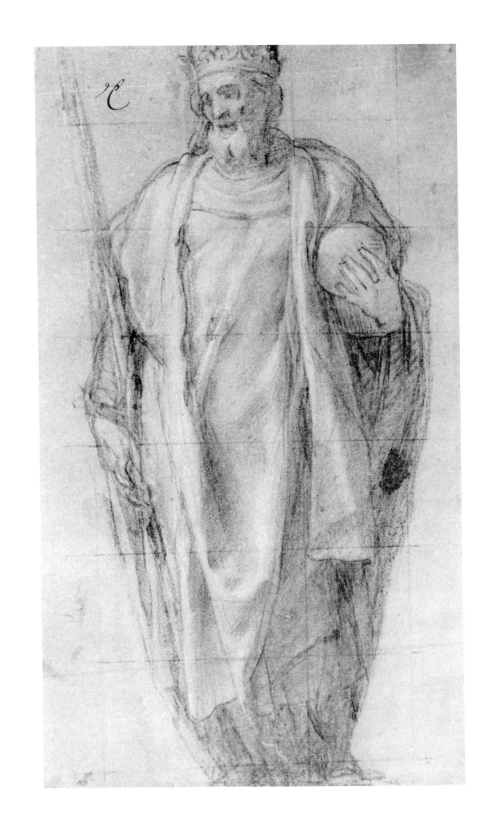

BATTISTA NALDINI

Florence 1537–Florence 1591

35 *Study for the Virgin, St. Agnes, St. Helena, and other Saints*

Red chalk, red wash. 10¹¹⁄₁₆ x 10¼ in. (27.2 x 26.0 cm.).

PROVENANCE: Entered the Museum National during the Revolution. Inventaire 10.306.

BIBLIOGRAPHY: Monbeig-Goguel, 1972, no. 96, repr. p. 96.

Roseline Bacou was the first to recognize this drawing as the work of Naldini; it was formerly classified amongst the anonymous Italian drawings at the Louvre. Catherine Monbeig-Goguel suggested a connection with the lower part of an altarpiece representing the Ascension of Christ in the Presence of the Virgin, St. Agnes, and St. Helena, an altarpiece the *modello* of which is preserved in the Ashmolean Museum, Oxford (P. Cannon Brookes, "Three Notes on Maso da San Friano," *Burlington Magazine*, CVII, 1965, fig. 31). The altarpiece, commissioned by Elena Ottonelli in 1564–65, was originally scheduled to be painted by Maso da San Friano, but after Maso's death in 1571 the commission was given to Naldini. Another drawing by Naldini for this part of the composition is in the collection of Edmund Pillsbury, New Haven (*The Age of Vasari*, exhibition catalogue, University of Notre Dame, Indiana, 1970, no. D 11, repr.).

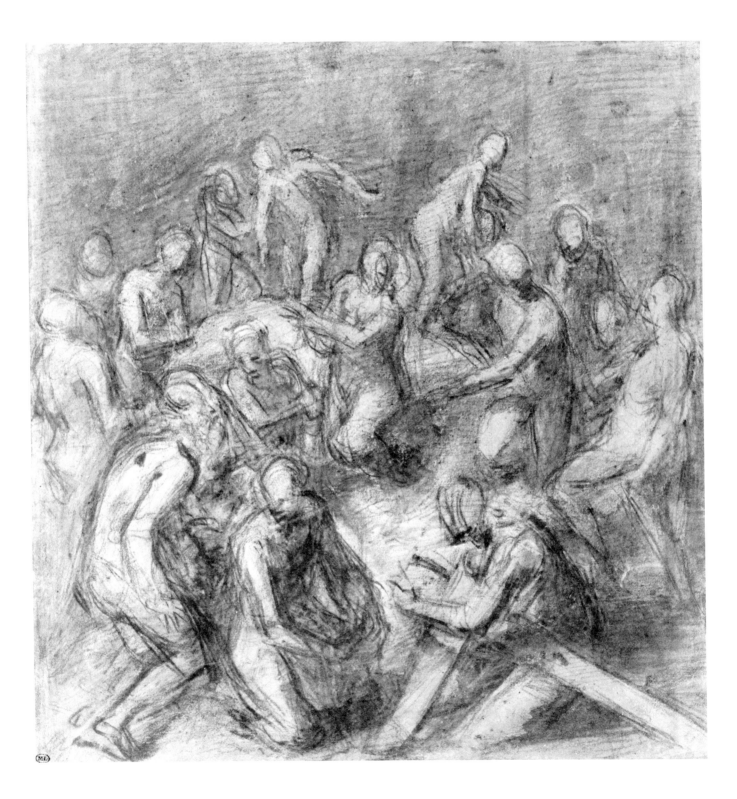

BATTISTA NALDINI

Florence 1537–Florence 1591

36 *Kneeling Youth*

Red chalk, traces of white heightening.
15⅞ x 9⁹⁄₁₆ in. (40.3 x 23.3 cm.).

PROVENANCE: Entered the Museum National
during the Revolution.
Inventaire 9551.

BIBLIOGRAPHY: Monbeig-Goguel, 1972, no.
93, repr. p. 89.

Study for the shepherd kneeling at the left in Naldini's *Adoration of the Shepherds* in S. Maria Novella, Florence (Venturi, IX, 5, fig. 145), which was finished in May 1573. A composition study for the picture is conserved in the Uffizi (705 F.). In the vigor of its chalk accents and in the reiteration of the contour lines, the drawing is typical of Naldini as a draughtsman, and of early Florentine mannerism.

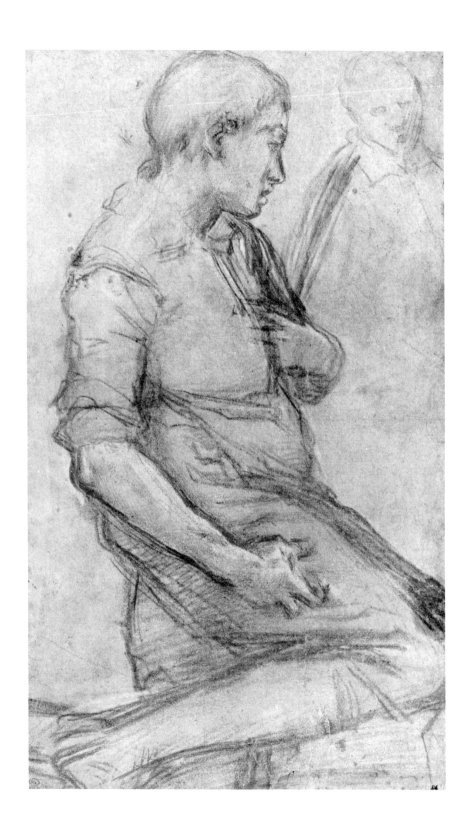

LELIO ORSI

Novellara 1511–Novellara 1587

37 *Allegory of the Setting Sun*

Pen and brown ink, brown wash, heightened with white, on beige paper. Squared off in black chalk. 7 x 16¹³⁄₁₆ in. (17.8 x 42.8 cm.).

PROVENANCE: Everhard Jabach (Lugt 2959 and 2953), with his gold border; Cabinet du Roi from 1671. Inventaire 10.379.

BIBLIOGRAPHY: Jabach Inventory, III, no. 390 (as Maturino); R. Bacou and F. Viatte, *Dessins de l'Ecole de Parme* (exhibition catalogue), Paris, 1964, under no. 105.

This drawing represents Apollo Driving the Chariot of the Sun, with the naked figure of Time at the left; above are the signs of Capricorn and Aquarius. It was one of a group of fourteen drawings, all from the Cabinet du Roi, formerly attributed to Maturino, then to the School of Giulio Romano, and recently restored to Lelio Orsi and his circle by Philip Pouncey. Of those drawings devoted to mythological themes, five represent Apollo Driving his Chariot, with the signs of the Zodiac (Inv. 5640, 10.378, 10.379, 10.380, 10.381). Another design for a frieze with an Apollo subject is conserved at Windsor Castle (Popham-Wilde, 1949, no. 534). The frieze-form composition recalls Lelio Orsi's decorations on house façades in his native town of Novellara.

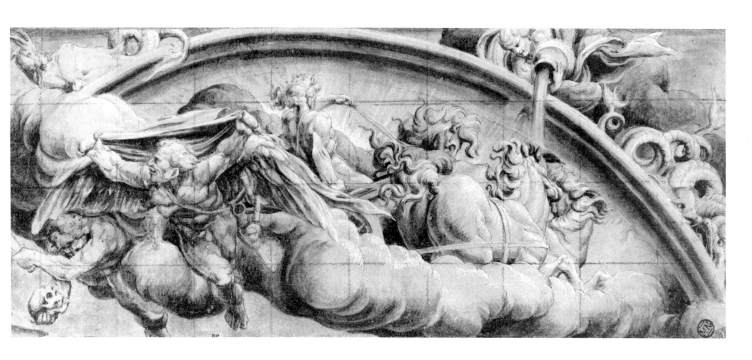

LELIO ORSI

Novellara 1511–Novellara 1587

38 *Allegory of the Life-Giving Force*
 of the Sun

Pen and brown ink, brown wash, heightened
 with white, on beige paper. Squared off in
 black chalk. 7⅛ x 16½ in. (18.1 x 42.0 cm.).

Numbered in pen and brown ink at lower left: *4*.

PROVENANCE: Everhard Jabach (Lugt 2959
 and 2953), with his gold border; Cabinet
 du Roi from 1671.
 Inventaire 10.380.

BIBLIOGRAPHY: Jabach Inventory, III, no. 388
 (as Maturino), R. Bacou and F. Viatte,
 Dessins de l'Ecole de Parme (exhibition
 catalogue), Paris, 1964, under no. 105.

Apollo in his chariot appears at the center, Jupiter and Mars are at
the left, and the Genius of Abundance is seen in the right fore-
ground running through a wheat field holding a torch and a cornu-
copia. This drawing is one of a group of designs by Lelio Orsi dis-
cussed in the preceding entry.

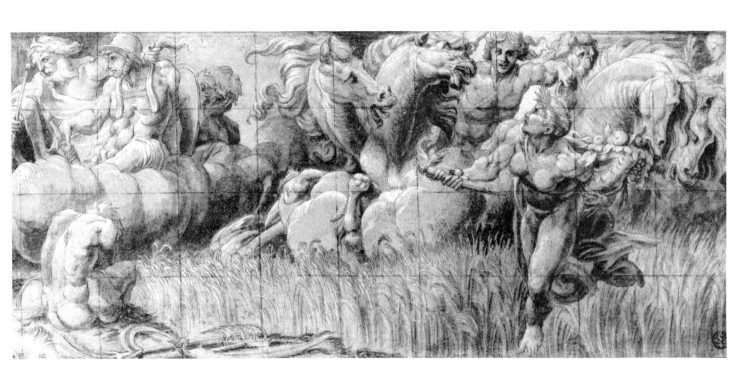

FRANCESCO MAZZOLA, called PARMIGIANINO

Parma 1503–Casalmaggiore 1540

39 *The Rape of Europa*

Red chalk. 12^{15}⁄$_{16}$ x 7^{15}⁄$_{16}$ in. (32.9 x 20.1 cm.).

PROVENANCE: Everhard Jabach (Lugt 2959), with his gold border; Cabinet du Roi from 1671.
Inventaire 6021.

BIBLIOGRAPHY: Jabach Inventory, II, no. 275 (as Parmigianino); Popham, 1952, pp. 21, 53, pl. II; A. E. Popham, "Drawings by Parmigianino for the Rocca of Fontanellato," *Master Drawings*, I, 1, 1963, p. 17, pl. 7; R. Bacou and F. Viatte, *Dessins de l'Ecole de Parme* (exhibition catalogue), Paris, 1964, no. 40, pl. VIII; Popham, 1971, no. 354, pl. 29.

It is interesting to note that this important drawing was attributed to Parmigianino in the inventory of Jabach's drawings prepared on the occasion of the purchase of the collection by Louis XIV in 1671. Classified in the course of the nineteenth century under the School of Correggio, it was published in 1952 by A. E. Popham as a particularly representative example of Parmigianino's earliest style. In 1963, pointing out the stylistic connections of the present drawing with a sheet of studies in Berlin with *Diana and Actaeon* on the recto and the *Rape of Europa* on the verso (Popham, 1963, pls. 2, 3), Popham suggested that the present drawing is an early project later rejected in favor of the story of Diana and Actaeon for the decoration commissioned by Gian Galeazzo Sanvitale for his castle at Fontanellato, and executed in 1524 before Parmigianino's departure for Rome. The Louvre possesses two studies for the Diana and Actaeon scenes at Fontanellato, a study for the *putti* playing with foliage who appear in the pendentives of the vault (Popham, 1971, no. 418, pl. 32), and a study of the head of a dog in the *Death of Actaeon* (Popham, 1971, no. 503, pl. 36).

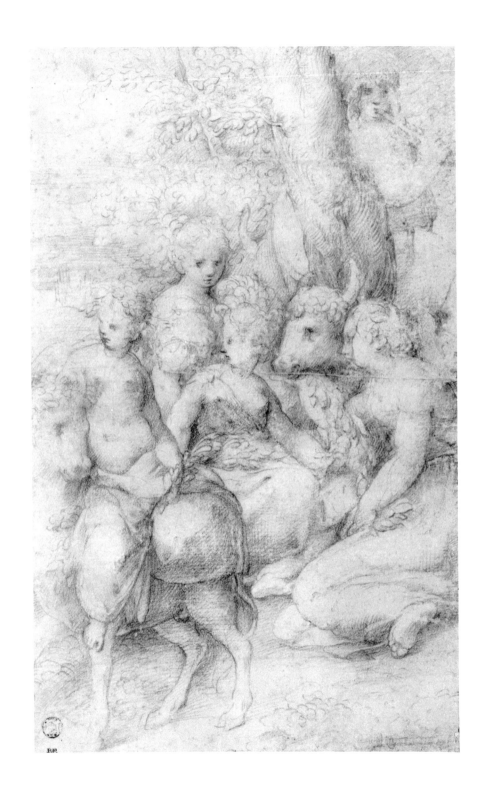

FRANCESCO MAZZOLA, called PARMIGIANINO

Parma 1503–Casalmaggiore 1540

40 *Seated Male Figure Accompanied by an Angel*

Pen and brown ink, brown wash, heightened with white. Squared off in black chalk. 9¾ x 7⁷⁄₁₆ in. (24.8 x 18.9 cm.).

Inscribed in pencil at lower left: *Parmegiano.*

PROVENANCE: Cabinet du Roi.
Inventaire 6422.

BIBLIOGRAPHY: S. J. Freedberg, *Parmigianino, His Works in Painting,* Cambridge, Mass., 1950, p. 252; R. Bacou and F. Viatte, *Dessins de l'Ecole de Parme* (exhibition catalogue), Paris, 1964, no. 45, pl. x; A. E. Popham, *Italian Drawings . . . in the British Museum: Artists Working in Parma . . . ,* London, 1967, under no. 64; Popham, 1971, no. 401, pl. 56.

A similar, but somewhat older male figure accompanied by two *putti* is studied in a drawing in the British Museum (Popham, 1971, no. 166, pl. 57); Popham related the two drawings to the decoration of the vaulting in the north transept of the Parma Cathedral, for which Parmigianino received the commission on November 21, 1522. The artist planned to fill the vaulted spaces with four figures, probably the Evangelists; the triangular space in which the figure is placed in the Louvre sketch does, in fact, suggest a section of the cross-vault. The Evangelist represented could be St. John accompanied by an angel and his attribute, the eagle, which appears to be lightly indicated at upper right. The influence of Correggio and of his *Apostles* in the cupola of S. Giovanni Evangelista (see No. 16) is particularly evident here, in the monumental conception of the principal figure, the foreshortening of the upturned face, as well as in the broad execution of the drawing.

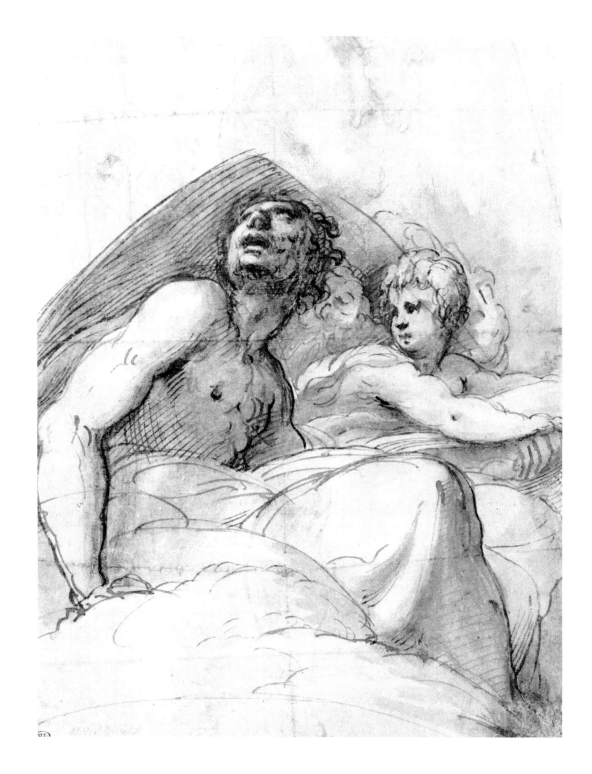

FRANCESCO MAZZOLA, called PARMIGIANINO

Parma 1503–Casalmaggiore 1540

41 *Holy Family with the Infant St. John*

Pen and brown ink, brown wash. 7⅜ x 10⅝ in. (18.8 x 27.0 cm.).

PROVENANCE: Everhard Jabach (Lugt 2961); Cabinet du Roi from 1671. Inventaire 6446.

BIBLIOGRAPHY: Jabach Inventory, II, no. 253 (as Parmigianino); Popham, 1952, pp. 22–23, pl. IX; R. Bacou and F. Viatte, *Dessins de l'Ecole de Parme* (exhibition catalogue), Paris, 1964, no. 51; Popham, 1971, no. 426, pl. 66.

In spite of the heroic monumentality of the figures, which already have a Roman air to them, the drawing must certainly date from before Parmigianino's departure for Rome in 1524, and it is a remarkable example of the artist's style in pen and wash around 1522–23. The fact that a drawing in the Fogg Museum (Popham, 1971, no. 823, pls. 473, 474) has on the verso a study for the figure of St. Joseph and on the recto figures that can be related to the decorations of S. Giovanni Evangelista, confirms this date. Popham has suggested that the present drawing is an early study for the *Rest on the Flight*, a painting from the Cook collection at Richmond, now belonging to Count Seilern in London (repr. S. J. Freedberg, *Parmigianino, His Works in Painting*, Cambridge, Mass., 1950, fig. 30), the composition of which, in spite of many variations, is related to that of the drawing. The latter was engraved in the eighteenth century by the Comte de Caylus (Weigel 5854).

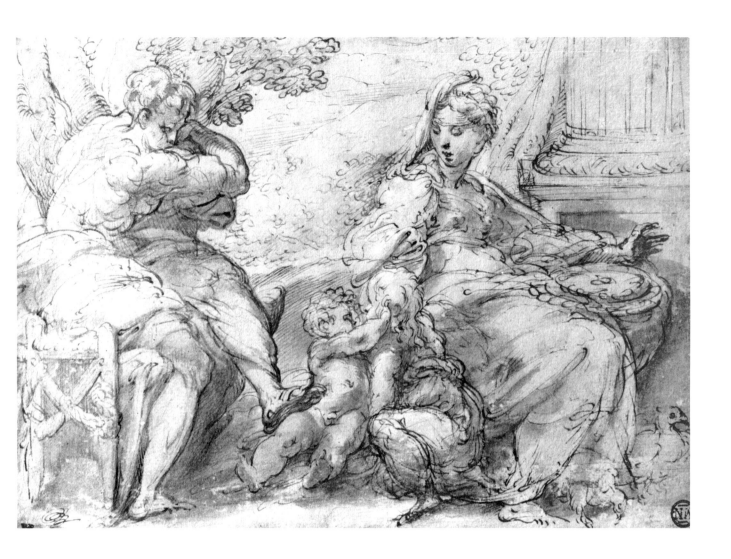

FRANCESCO MAZZOLA, called PARMIGIANINO

Parma 1503–Casalmaggiore 1540

42 *Martyrdom of St. Peter and St. Paul*

Pen and brown ink, brown wash, heightened
 with white, over black chalk.
 6¹⁵⁄₁₆ x 10⁵⁄₁₆ in. (17.7 x 26.2 cm.).

PROVENANCE: Everhard Jabach (Lugt 2961);
 Cabinet du Roi from 1671.
 Inventaire 6400.

BIBLIOGRAPHY: Jabach Inventory, II, no. 246
 (as Parmigianino); R. Bacou and F. Viatte,
 Dessins de l'Ecole de Parme (exhibition
 catalogue), Paris, 1964, no. 61, pl. xv; A. E.
 Popham, *Italian Drawings . . . in the British
 Museum: Artists Working in Parma . . .*,
 London, 1967, under no. 88; Popham,
 1971, no. 380, pl. 137.

A study dating from the time of the artist's stay in Rome in 1524–27, for the composition known through Jacopo Caraglio's engraving (Bartsch, XX, p. 71, no. 8; repr. Popham, 1971, fig. 19) and Antonio da Trento's chiaroscuro print (Bartsch, XII, p. 79, no. 28; repr. Popham, 1971, fig. 21). In the drawing the executioner replaces his sword in its sheath after decapitating St. Paul, while Nero, pointing at St. Peter, gives the order for his crucifixion. The Louvre possesses another composition study with variations, in the same technique, and of the same provenance (Popham, 1971, no. 379, pl. 136); a more highly finished version in the British Museum no doubt represents the most advanced stage of the composition (ibid., no. 190, pl. 135). This subject may have been studied by Parmigianino for the decoration of the Sala dei Pontefici in the Vatican, a commission that Pope Clement VII thought of giving to Parmigianino.

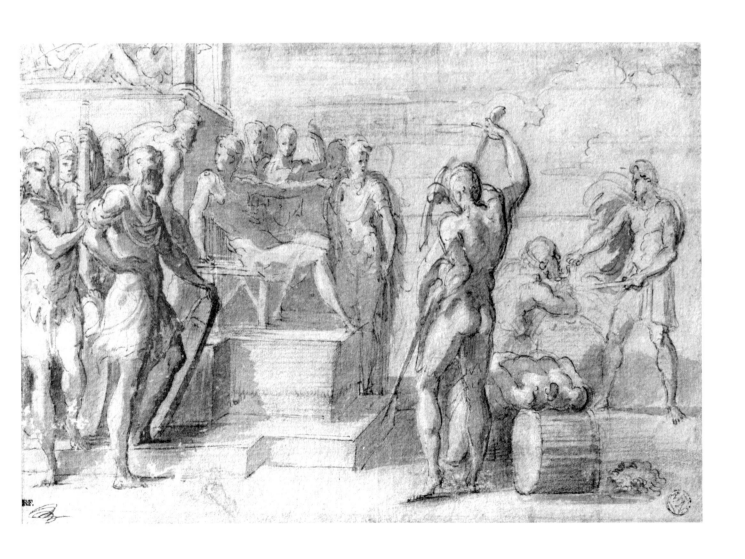

FRANCESCO MAZZOLA, called PARMIGIANINO

Parma 1503–Casalmaggiore 1540

43 Two Studies of John the Baptist in the Wilderness

(a) *The Baptist Facing Right Drinking from a Cup*

Pen and brown ink, brown wash, heightened
 with white, on gray blue paper.
 4¹¹⁄₁₆ x 4³⁄₁₆ in. (12.0 x 10.7 cm.).
 All four corners replaced.

PROVENANCE: Everhard Jabach; Cabinet du
 Roi from 1671.
 Inventaire 6391.

BIBLIOGRAPHY: Jabach Inventory, II, no. 240
 (as Parmigianino); G. Copertini, *Il Parmi-
 gianino*, Parma, 1932, pl. CXLII b; Popham,
 1952, p. 32, note 2; R. Bacou and F. Viatte,
 Dessins de l'Ecole de Parme (exhibition
 catalogue), Paris, 1964, no. 73, pl. XVI;
 Popham, 1971, no. 370, pl. 116.

(b) *The Baptist Facing Left Drinking from a Cup*

Pen and brown ink, brown wash, heightened
 with white, on gray blue paper.
 6⅝ x 4½ in. (16.8 x 11.5 cm.).

PROVENANCE: Everhard Jabach (Lugt 2961);
 Cabinet du Roi from 1671.
 Inventaire 6391 bis.

BIBLIOGRAPHY: Jabach Inventory, II, no. 261
 (as Parmigianino); Popham, 1952, p. 32,
 note 2; R. Bacou and F. Viatte, *Dessins de
 l'Ecole de Parme* (exhibition catalogue),
 Paris, 1964, no. 72; Popham, 1971, no. 371,
 pl. 116.

Two studies on the theme of St. John the Baptist in the Wilderness, a composition utilized in a chiaroscuro print signed by Antonio da Trento (Bartsch, XII, p. 73, no. 17; repr. Popham, 1971, fig. 22). A third study, in the Louvre, in which the Saint caresses a lamb, comes closer to the composition reproduced in the woodcut (Popham, 1971, no. 415, pl. 115). A. E. Popham described nine studies for this subject, pointing out that the style of the drawings indicates the end of Parmigianino's Roman period, or the time of his stay in Bologna from 1527 to 1530. He suggested a possible connection with the *Vision of St. Jerome*, a painting now in the National Gallery, London, that the artist finished at the moment of the entry into Rome of the troops of the Connétable de Bourbon in May 1527, and in which an important place in the foreground is given to the figure of St. John the Baptist. No. 43b was engraved by the Comte de Caylus in the *Recueil du Cabinet du Roi*.

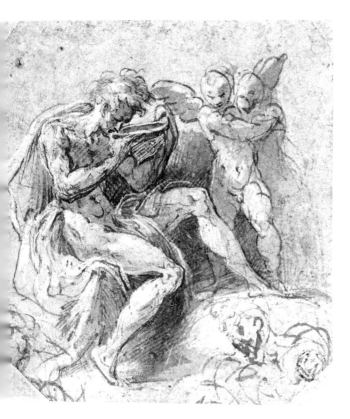

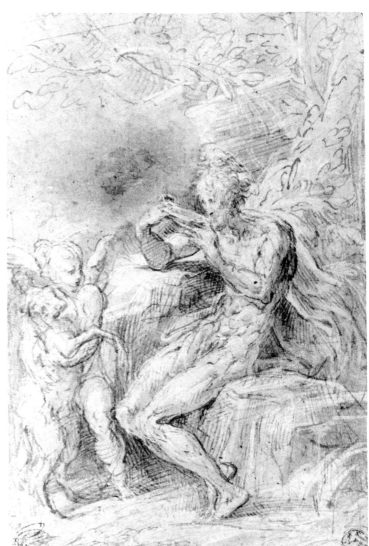

FRANCESCO MAZZOLA, called PARMIGIANINO

Parma 1503–Casalmaggiore 1540

44 *Figures Gathered around a Small Table*

Pen and brown ink. 7$\frac{11}{16}$ x 10 in.
(19.5 x 25.5 cm.).

PROVENANCE: Entered the Museum National during the Revolution.
Inventaire 6499.

BIBLIOGRAPHY: Popham, 1952, p. 34; R. Bacou and F. Viatte, *Dessins de l'Ecole de Parme* (exhibition catalogue), Paris, 1964, no. 94; Popham, 1971, no. 480, pl. 436.

A remarkable study of daily life recorded by the artist with a nervous, expressive pen line, in elliptical perspective. This sketch of figures seated around a table is directly observed from nature in the same way as the no doubt contemporary studies of men in a boat in the British Museum (Popham, 1971, no. 224, pl. 438) and in the Louvre (ibid., no. 406, pl. 437), and the views of studio interiors at Besançon (ibid., no. 22, pl. 439) and the Pierpont Morgan Library (ibid., no. 321, pl. 439). All these drawings may be placed in the last period of the artist's activity, between 1530 and 1540.

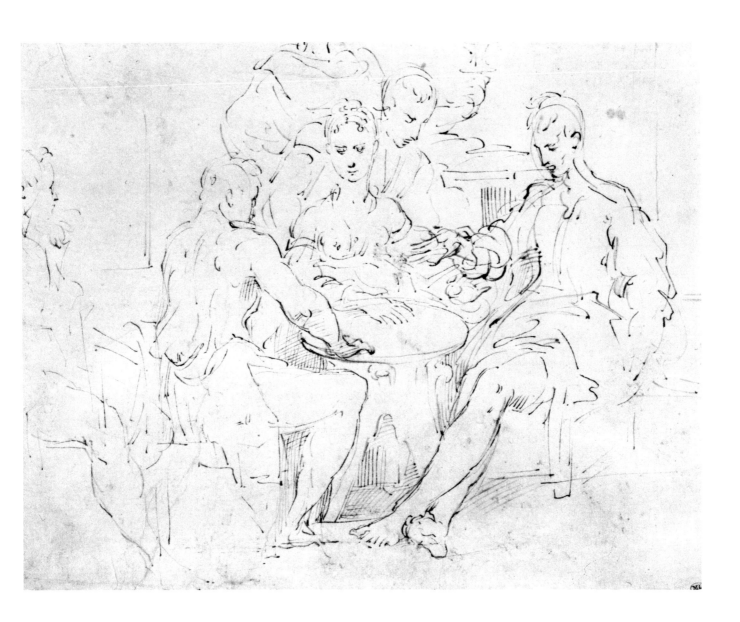

LUCA PENNI

Florence, about 1500/1504–Paris 1556

45 *The Three Marys at the Tomb*

Pen and brown ink, brown wash, heightened
with white, on brown-washed paper.
11⅞ x 18⅛ in. (30.2 x 46.0 cm.).

Inscribed in pencil at lower right: *Penni.*

PROVENANCE: Entered the Museum National
during the Revolution.
Inventaire 1394.

BIBLIOGRAPHY: L. Golson, "Lucca Penni, a
Pupil of Raphael at the Court of Fontaine-
bleau," *Gazette des Beaux Arts*, II, 1957,
p. 31, fig. 8; G. Monnier, *Le XVI⁰ siècle
européen: Dessins du Louvre* (exhibition
catalogue), Paris, 1965, no. 138, pl. XXXIII;
S. Béguin, *Il Cinquecento francese*, Milan,
1970, p. 90, fig. 21; R. Bacou, *L'Ecole de
Fontainebleau* (exhibition catalogue),
Paris, 1972–1973, no. 137, repr.

Raphael's influence is still evident in this drawing, one of the most
important and characteristic surviving drawn works of Luca Penni,
a Florentine artist who, after having worked in Rome for Raphael,
in Lucca and Genoa with his brother-in-law Perino del Vaga, came
to France around 1530 to participate in the decoration of the Châ-
teau de Fontainebleau. The landscape background at the left recalls
those that appear in scenes of the *Histoire de Diane* conserved at
the Musée des Beaux-Arts in Rennes and in the Louvre (Inv. 8741
and 8742). The harmonious solemnity of the composition with its
center in the three draped figures is characteristic of Penni's classi-
cizing tendencies in his French period.

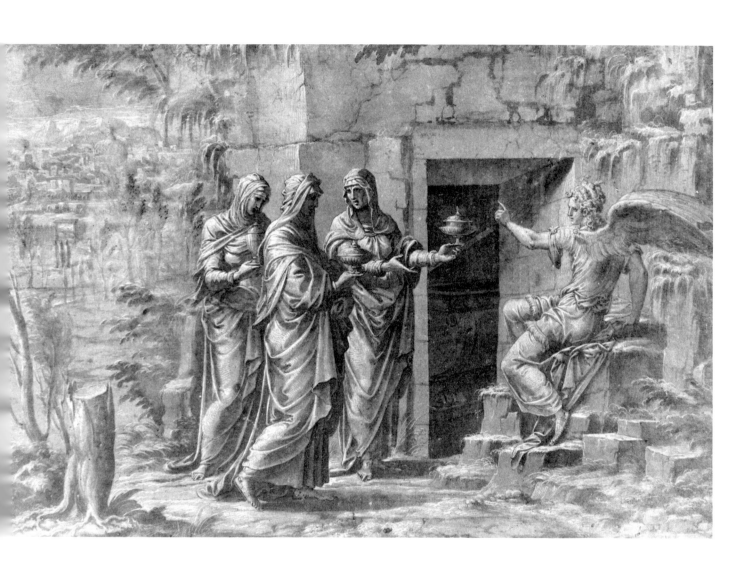

PIERO BUONACCORSI, called PERINO DEL VAGA

Florence 1501–Rome 1547

46 *Study for the Dead Figure of Christ*

Red chalk. 11⁹⁄₁₆ x 15⁹⁄₁₆ in. (29.4 x 39.5 cm.).
Upper margin repaired.

PROVENANCE: Cabinet du Roi.
Inventaire 631.

BIBLIOGRAPHY: B. Davidson, *Disegni di Perino del Vaga e la sua cerchia* (exhibition catalogue), Florence, 1966, no. 5, fig. 7, and under no. 6.

This powerful study for the figure of the Dead Christ was connected by Bernice Davidson with the *Deposition* painted by Perino del Vaga for the altar of a chapel in S. Maria sopra Minerva in Rome, of which only two fragments survive at Hampton Court (B. Davidson, "Early Drawings by Perino del Vaga," *Master Drawings*, I, no. 3, 1963, pp. 8–9). The position of the figure, drawn realistically after life, is close to that adopted by Perino in the composition study for the *Deposition* in the British Museum (ibid., 1963, pl. 3). The study of a left arm with the hand open, derived from the *Adam* of the Sistine Chapel, is probably that of the seated St. John the Baptist who appears at the left in the composition study in the British Museum.

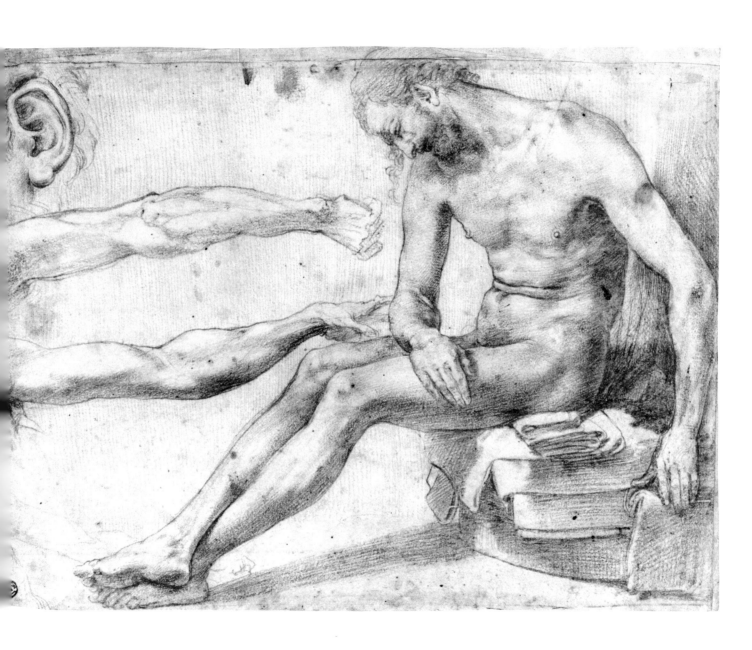

PIERO BUONACCORSI, called PERINO DEL VAGA

Florence 1501–Rome 1547

47 *Study of the Seated Figure of St. Luke*

Black chalk and gray wash. 15⅝₆ x 10¾ in. (38.9 x 27.4 cm.).

PROVENANCE: Everhard Jabach (Lugt 2961); Cabinet du Roi from 1671. Inventaire 2814.

BIBLIOGRAPHY: Jabach Inventory, III, no. 631 (as Perino del Vaga); B. Davidson, *Disegni di Perino del Vaga e la sua cerchia* (exhibition catalogue), Florence, 1966, no. 46, fig. 38; M. Hirst, "Perino del Vaga and his Circle," *Burlington Magazine*, CVIII, 1966, p. 402; F. Sricchia Santoro, "Daniele da Volterra," *Paragone*, 213/33, 1967, p. 15; J. A. Gere, *Dessins de Taddeo et Federico Zuccaro* (exhibition catalogue), Paris, 1969, no. 5.

This drawing, as well as a pendant study of St. Matthew (Inv. 2815), was recognized by Philip Pouncey amongst the anonymous Italian drawings as Perino's study for the figure of St. Luke in the Chapel of the Crucifixion in S. Marcello al Corso, Rome. The decoration of the vault includes a representation of the Creation of Eve and the figures of the four Evangelists accompanied by *putti*. Bernice Davidson in 1966 traced the history of this commission, which was executed in two stages, and she has studied the various preparatory drawings (Florence exhibition catalogue, nos. 11, 45, 46). Begun before the sack of Rome in 1527 but left unfinished, the decoration was taken up again by Perino on his return from Genoa in 1539. Perino then confided the task of executing the frescoes, after his own designs, to Daniele da Volterra. The frescoes representing St. Luke and St. Matthew date from this second period of work in the Chapel, as must the two Louvre drawings which are quite close to the finished paintings. Miss Davidson remarks that this monumental figure of St. Luke could have been inspired by Michelangelo's *Prophet Isaiah* on the ceiling of the Sistine Chapel.

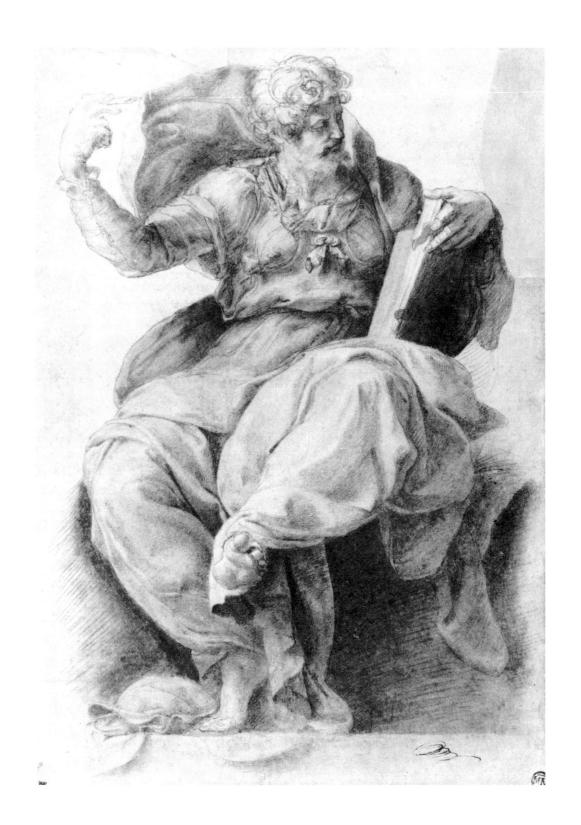

PIERO BUONACCORSI, called PERINO DEL VAGA

Florence 1501–Rome 1547

48 *Design for a Façade Decoration*

Pen and brown ink, gray wash. 16⅞ x 10¾ in. (42.9 x 27.3 cm.).

Inscribed in pen and brown ink at upper margin: *Pierino del vago.*

PROVENANCE: Gelosi (Lugt 545); entered the Museum National during the Revolution. Inventaire 602.

BIBLIOGRAPHY: B. Davidson, *Disegni di Perino del Vaga e la sua cerchia* (exhibition catalogue), Florence, 1966, no. 44, fig. 39; M. Hirst, "Perino del Vaga and his Circle," *Burlington Magazine*, CVIII, 1966, p. 405, note 19; G. Monnier, *Dessins d'Architecture du XV° au XIX° siècle* (exhibition catalogue), Paris, 1972, no. 12.

This project for the decoration of the façade of a palace cannot be connected with any surviving decoration by Perino or with any scheme described by his biographers. Bernice Davidson has compared the different constituent elements of the scheme—narrative scenes, figures in niches, and pairs of *putti* above the windows—with Perino's projects for the façade of the Palazzo Doria in Genoa and called attention to the connection of this kind of decorative scheme, inspired by the examples of Peruzzi and Polidoro da Caravaggio, with decorations for triumphal arches. Miss Davidson also connected this drawn scheme with the Farnese family: the large coat of arms at upper center is that of Pope Paul III; below this appear the arms of Cardinal Alessandro Farnese, of Pier Luigi Farnese, and perhaps those of Ranuccio Farnese, who, as Michael Hirst pointed out, was created Cardinal in 1545. Thus the drawing would be datable to the last years of Perino's life.

PIERO BUONACCORSI, called PERINO DEL VAGA

Florence 1501–Rome 1547

49 *Two Studies for Medallions*

(a) *Apollo and Hyacinth*
Red chalk. 4⁹⁄₁₆ x 2¹⁵⁄₁₆ in. (11.7 x 7.5 cm.).

(b) *Nude Boy and Girl Embracing*
Red chalk. 4¹¹⁄₁₆ x 3 in. (12.0 x 7.7 cm.).

PROVENANCE: Everhard Jabach (Lugt 2959
and 2953), with his gold border; Cabinet
du Roi from 1671.
Inventaire 10.383 and 10.383 bis.

BIBLIOGRAPHY: Jabach Inventory, III, nos. 459
and 460 (as Perino del Vaga); B. Davidson,
Disegni di Perino del Vaga e la sua cerchia
(exhibition catalogue), Florence, 1966, no.
13, fig. 14, no. 14.

These two drawings were recognized by Bernice Davidson amongst the anonymous Italian drawings. A third study, also from the Jabach collection, representing a Nude Man Holding a Cornucopia, was found at the Louvre amongst the anonymous French drawings (Inv. 33.446). The three drawings, of comparable dimensions, belong to a series probably intended to be engraved; they are characterized by a precise and delicate technique that would suggest a utilization for engraving on semiprecious stone. Miss Davidson relates the drawing of the *Nude Boy and Girl Embracing* to a cameo of the same subject conserved in the Archaeological Museum, Florence. The *Apollo and Hyacinth*, inspired by Ovid's *Metamorphoses*, was engraved in reverse by H. van der Borcht with the caption: *P. del Vaga in.*

BALDASSARE PERUZZI

Siena 1481–Rome 1536

50 *The Last Supper*

Pen and brown ink, black and red chalk.
13½ x 9⅝ in. (34.3 x 24.5 cm.).

Inscribed in pen and brown ink at lower right:
R. da Urbino (?).

PROVENANCE: Entered the Museum National
during the Revolution.
Inventaire 5634.

BIBLIOGRAPHY: C. L. Frommel, *Baldassare
Peruzzi als Maler und Zeichner*, Vienna,
1967/1968, no. 65, pl. XXXIII b.

In this drawing, first attributed to Peruzzi by Philip Pouncey and dated by Frommel about 1517–18, Peruzzi rejects the traditional format of representations of the Last Supper and adopts a vertical format which imposes a closer grouping of the figures; the table is L-shaped and Judas is seated opposite Christ. Frommel has remarked that the original sheet must have been somewhat wider since the twelfth Apostle, who would have sat or stood at the left, is absent. The fighting dog and cat in the foreground add a surprising note of vivacious realism to the sacred scene.

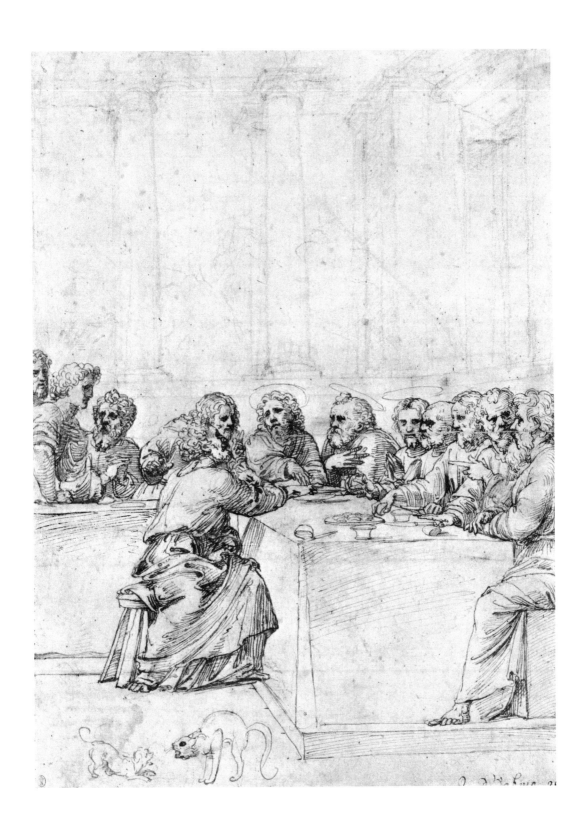

BALDASSARE PERUZZI

Siena 1481–Rome 1536

51 *The Discovery of Fire*

Pen and brown ink. Squared off in red chalk. 6½ x 7¹¹⁄₁₆ in. (16.5 x 19.6 cm.).

Numbered in pen and brown ink at lower right: *31.*

PROVENANCE: Entered the Museum National during the Revolution. Inventaire 12.329.

BIBLIOGRAPHY: C. L. Frommel, *Baldassare Peruzzi als Maler und Zeichner*, Vienna, 1967/68, no. 64, pl. XXXIII c.

Philip Pouncey identified this drawing as the work of Peruzzi amongst the anonymous Italian drawings, and Frommel dated it around 1517–18. In style it is similar to Peruzzi's work in the Ponzetti Chapel in S. Maria della Pace, Rome, dated 1516 (repr. Frommel, pl. XXVII), and to the frescoes executed from 1519 in the Cancelleria. One of the Cancelleria compositions, representing Adam and Eve in a Landscape, is particularly close to the present scene (repr. ibid., pl. XLIb.). In this representation of the Discovery of Fire, which appears to be the subject of the drawing, Peruzzi may have been inspired by a woodcut illustration to Fra Giocondo's 1511 edition of Vitruvius (ibid., p. 106).

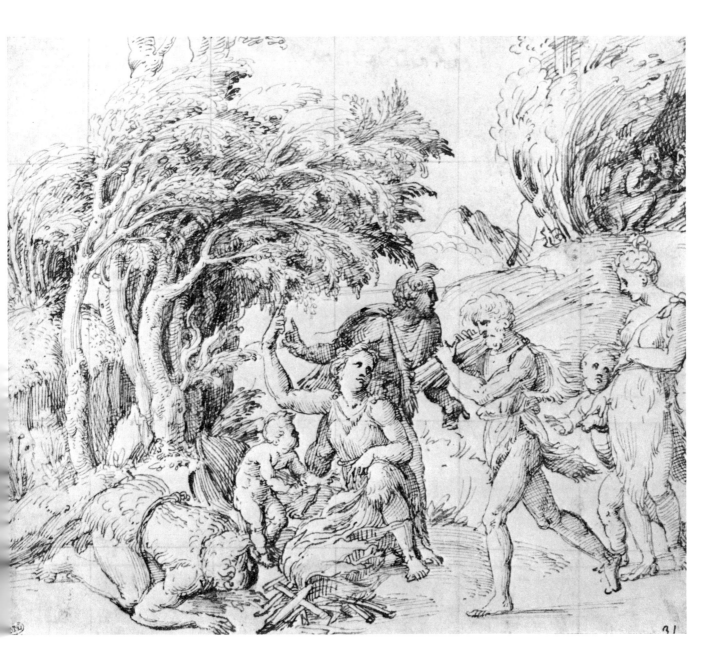

BALDASSARE PERUZZI

Siena 1481–Rome 1536

52 *Satirical Allegory: Mercury being Purged in a City Square*

Pen and brown ink, brown wash.
9³⁄₁₆ x 16⁵⁄₈ in. (23.4 x 42.2 cm.).

Numbered in pen and black ink at lower right:
22.

PROVENANCE: Giorgio Vasari; Pierre Crozat;
P.-J. Mariette (Lugt 1852); Mariette sale,
Paris, 1775, no. 584; Cabinet du Roi.
Inventaire 1419.

BIBLIOGRAPHY: Vasari, III, p. 610; O. Kurz,
"Giorgio Vasari's *Libro de' Disegni,*" *Old
Master Drawings,* XII, June, 1937, pl. 12,
and XII, December, 1937, p. 35; C. L.
Frommel, *Baldassare Peruzzi als Maler und
Zeichner,* Vienna, 1967/1968, no. 125, pl.
LXXVI; R. Bacou, *Il Paesaggio nel disegno
del cinquecento europeo* (exhibition cata-
logue), Rome, 1972/1973, no. 121, repr.

This drawing belonged to a number of illustrious collectors—in the sixteenth century to Giorgio Vasari, who kept it in his *Libro de' Disegni* and who described it in his Life of Peruzzi, in the eighteenth century to Crozat, and then to Mariette. It was acquired for the Cabinet du Roi at the sale of Mariette's collection in 1775. Various interpretations of the subject have been proposed: for Vasari it was a satire on druggists and alchemists, while for others it was a satire on certain artists more concerned with enriching themselves than with perfecting their art. Raphael, Michelangelo, Sebastiano del Piombo, and Giovanni da Udine are said to be represented at the left in the group of the Pure, while Bramante and Giuliano da San Gallo are represented amongst the Rapacious. The influence of the contemporary theater is evident: the figures appear on a stage set in the center of a square of an ideal city where real classical monuments (on the left the Colosseum and the Arch of Constantine) are mixed with imaginary structures. Frommel dates the drawing quite late in the artist's career, around 1530–32.

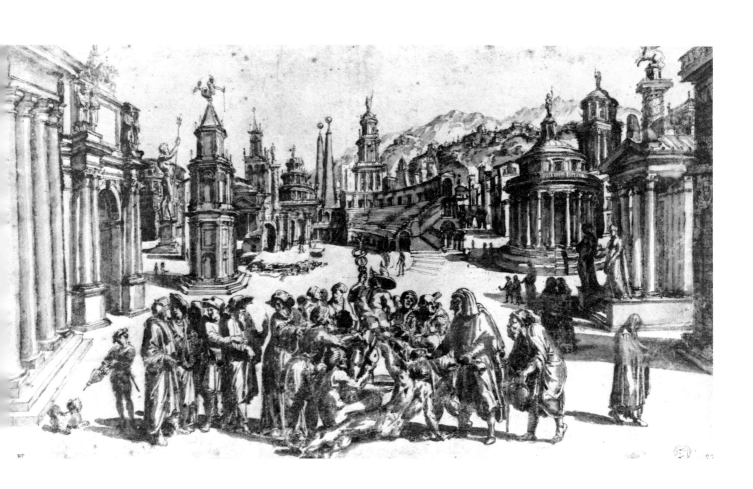

POLIDORO CALDARA, called POLIDORO DA CARAVAGGIO

Caravaggio 1490/1500–Messina 1543?

53 *Figures Fleeing from the Flood*

Pen and brown ink, brown wash, heightened with white, on blue paper. 9⁵/₁₆ x 16 in. (23.7 x 40.7 cm.).

Inscribed in brush and white gouache at lower left: *Polidor.*

PROVENANCE: Desneux de la Noue; Everhard Jabach (according to an old pen inscription on the verso); entered the Museum National during the Revolution. Inventaire 6065.

BIBLIOGRAPHY: Popham-Wilde, 1949, under no. 735; E. Borea, "Vicenda di Polidoro," *Arte Antica e Moderna*, 13–16, 1961, p. 220; M. Rotili, *Fortuna di Michelangelo nell'incisione* (exhibition catalogue), Benevento, 1964, p. 83, under no. 78; B. Davidson, *Disegni di Perino del Vaga e la sua cerchia* (exhibition catalogue), Florence, 1966, under no. 17; A. Marabottini, *Polidoro da Caravaggio*, Rome, 1969, no. 27, pl. LXXIV, 4.

This drawing was engraved by Battista Franco (Bartsch, XVI, p. 155, no. 3), and it has been suggested that the drawing itself is the work of Franco (Rotili, 1964). This hypothesis is untenable, for the Louvre *Flood* is one of Polidoro's most important drawings, executed in Rome before his departure for Naples. The Louvre possesses a copy of the drawing by Battista Franco that was no doubt preparatory to the engraving; the copy comes from the collection of Jabach where it was attributed to Maturino (Inv. 4917). A second copy is preserved at Windsor Castle (Popham-Wilde, 1949, no. 735).

The composition does not correspond to any surviving painting by Polidoro; it is inspired by Michelangelo's *Deluge* in the Sistine Chapel, while several details derive from Raphael, principally the figure of the nude man standing on his toes in the right foreground, who is taken from the *Fire in the Borgo*. Themes of flood and shipwreck appear on several occasions on decorations by the school of Raphael, for example in the monochrome frescoes in the Sala di Costantino, now attributed to Polidoro (Marabottini, 1969, pl. XI–6). Bernice Davidson very rightly points out the close connection between this drawing and the sutdy in the Uffizi for the *Shipwreck of Aeneas*, executed by Perino del Vaga for the Palazzo Doria in Genoa a few years later.

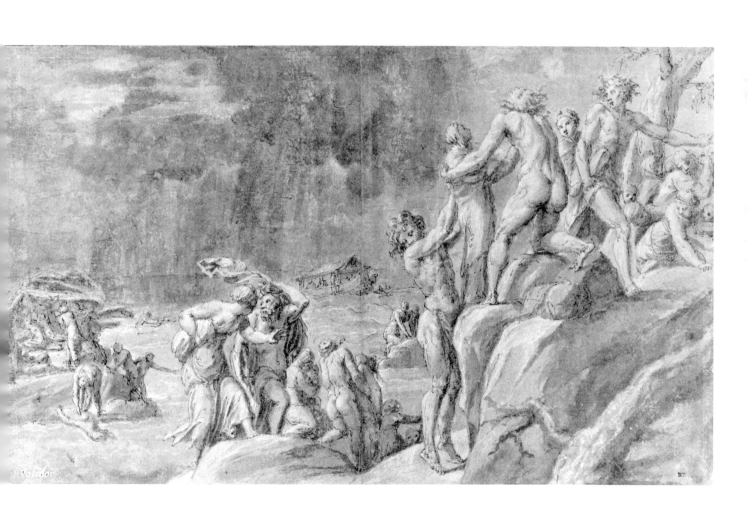

POLIDORO CALDARA, called POLIDORO DA CARAVAGGIO

Caravaggio 1490/1500–Messina 1543?

54 *The Meeting of Janus and Saturn*

Red chalk on brownish paper. 7¾ x 11⁹⁄₁₆ in. (19.7 x 28.4 cm.).

PROVENANCE: Roger de Piles; Pierre Crozat; Crozat sale, Paris, 1741, no. 163; Comte de Saint-Morys; entered the Museum National during the Revolution. Inventaire 6078.

BIBLIOGRAPHY: E. Borea, "Vicenda di Polidoro," *Arte Antica e Moderna*, 13–16, 1961, p. 216; R. Kultzen, "Der Freskenzyklus in der ehemaligen Kapelle der Schweizergarde in Rom," *Zeitschrift für schweizerische Archäologie und Kunstgeschichte*, no. 21, 1961, p. 29, repr. pl. 21 C.; F. Viatte, *Le XVI° siècle européen: Dessins du Louvre* (exhibition catalogue), Paris, 1965, no. 117, pl. XXIX; A. Marabottini, *Polidoro da Caravaggio*, Rome, 1969, pp. 69, 88, 304, no. 25, pl. XX, 2.

First sketch for one of the four scenes of Roman history painted by Polidoro in the *Salone* of the Villa Lante in Rome, and today preserved in the Biblioteca Hertziana. The Villa Lante was built from 1518 by Giulio Romano for Baldassare Turini, a friend of Pope Leo X. The identification of this drawing, datable from 1524–25, helps to establish a chronology for the drawn work of Polidoro, and in addition enables us to attribute with greater certainty to Polidoro the scenes of Roman history in the Villa Lante previously given to Giulio Romano or his workship. The drawing is thus described by Mariette in his catalogue of the Crozat sale: "The meeting of Saturn and Janus, a beautiful red chalk drawing from the collection of M. de Piles; he had brought it from Portugal with a good part of the drawings by Polidoro that are in this collection: their remarkable beauty led some to think that they were by Raphael." This drawing was engraved in 1787 by the Comte de Saint-Morys for the selection of 119 plates after drawings in his collection, which entered the Museum National during the Revolutionary years (Bibliothèque Nationale Estampes, Aa 18 fol.).

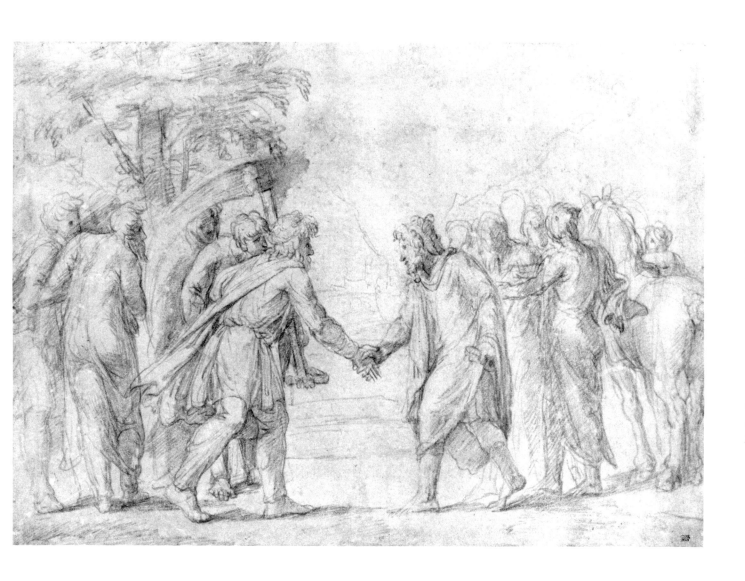

POLIDORO CALDARA, called POLIDORO DA CARAVAGGIO

Caravaggio 1490/1500–Messina 1543?

55 *Card Players around a Table*

Red chalk. 6⁹⁄₁₆ x 8¼ in. (16.7 x 21.0 cm.).

PROVENANCE: Agostino Scilla; Pierre Crozat; Crozat sale, Paris, 1741, part of no. 166; P.-J. Mariette (Lugt 1852), his mount with cartouche: POLIDORI CARAVAGIENSIS; Mariette sale, Paris, 1775, part of no. 263; Comte de Saint-Morys; entered the Museum National during the Revolution. Inventaire 6095.

BIBLIOGRAPHY: A. Marabottini, *Polidoro da Caravaggio*, Rome, 1969, p. 303, no. 24, pl. LXXIV, 2.

The lively abbreviated draughtsmanship and very idiosyncratic facial types relate this drawing to a whole group of genre scenes by Polidoro, probably studied after nature. Their rather unexpected subject matter sets them apart in Roman draughtsmanship of the sixteenth century, as well as in Polidoro's own work. Like No. 56, this drawing was part of a group of the artist's drawings from the collection of the painter Agostino Scilla (1629–1700) acquired by Mariette at the Crozat sale. Unlike the rest of the drawings in the group the present study dates from Polidoro's Roman rather than his Sicilian period, as Marabottini has pointed out. The drawing was engraved by the Comte de Saint-Morys in 1788.

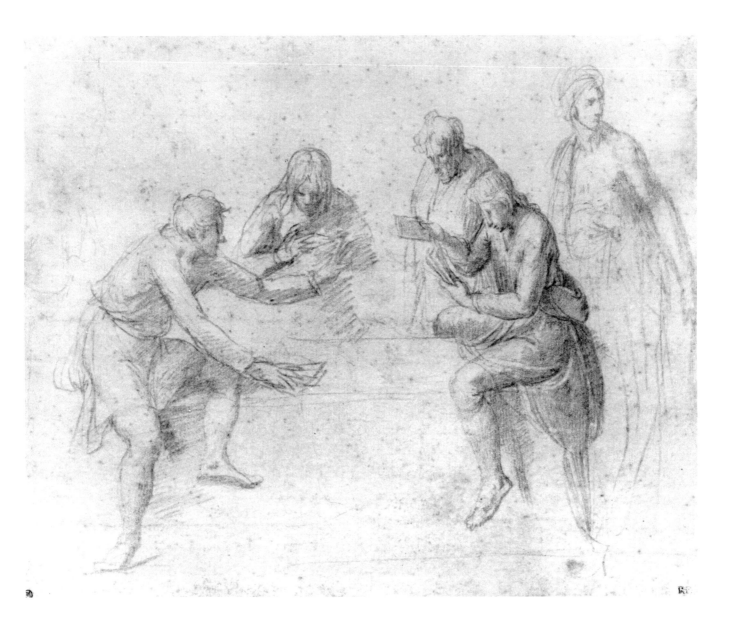

POLIDORO CALDARA, called POLIDORO DA CARAVAGGIO

Caravaggio 1490/1500–Messina 1543?

56 *Head of a Sleeping Child and Studies of Hands*

Pen and brown ink on brownish paper. 9¹¹⁄₁₆ x 6⅜ in. (24.7 x 16.3 cm.).

Numbered in pen and brown ink at lower right: *14*.

PROVENANCE: Agostino Scilla; Pierre Crozat; Crozat sale, Paris, 1741, part of no. 166; P.-J. Mariette (Lugt 1852), his mount with cartouche: POLIDORI CARAVAGIENSIS; Mariette sale, Paris, 1775, probably part of no. 268; Cabinet du Roi. Inventaire 6098.

BIBLIOGRAPHY: A. Marabottini, "Genesi di un dipinto (L'Andata al Calvario di Polidoro a Capodimonte)," *Commentari*, XVIII, 1967, p. 184, note 24, fig. 11; A. Marabottini, *Polidoro da Caravaggio*, Rome, 1969, p. 324, no. 103, pl. XCIX.

One of the most remarkable drawings dating from the last period of Polidoro's activity. It is one of his rare sketches executed in pen alone, with precise and rigorous crosshatched strokes, and the effect he echieves is strikingly realistic. Marabottini dates the drawing at the time of the stay in Messina, a period in Polidoro's career that is still relatively unknown, with the exception of the *Way to Calvary*, a painting now in the Museo di Capodimonte in Naples. This sketch was part of a lot of "soixante-cinq esquisses ou premières pensées diverses à la plume," that Mariette purchased at the Crozat sale in 1741, and which had been brought together in Sicily by Agostino Scilla.

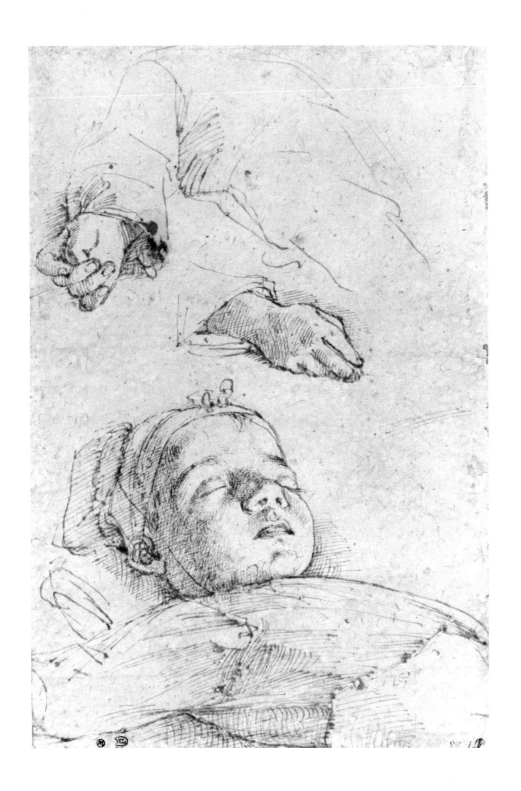

JACOPO DA PONTORMO

Pontormo 1494–Florence 1557

57 *Standing Male Nude*

Red chalk. 15¾ x 11¾₁₆ in. (40.1 x 28.5 cm.).

Inscribed in pen and brown ink at lower left: *Jacopo da Pontormo.*

PROVENANCE: Cabinet du Roi.
 Inventaire 1015.

BIBLIOGRAPHY: R. Bacou, *Dessins de maîtres florentins et siennois* (exhibition catalogue), Paris, 1955, no. 69; Berenson, 1961, II, no. 2327; J. Cox Rearick, *The Drawings of Pontormo*, Cambridge, 1964, no. A322; J. Cox Rearick, "The Drawings of Pontormo: Addenda," *Master Drawings*, VIII, 4, 1970, p. 369, no. 190 a, pl. 7 b (with previous bibliography); J. Shearman, "J. Cox Rearick's 'The Drawings of Pontormo'" (review), *Art Bulletin*, LIV, 2, 1972, pp. 210–212.

This study had been generally accepted as an original by Pontormo until Janet Cox Rearick, in 1964, suggested that it was the work of Pontormo's student Naldini, to whom she also attributed another nude study in the Louvre (Inv. 1017; Cox Rearick, A324). Naldini was indeed responsible for many copies of Pontormo's drawings, specifically those datable to the years 1519–21. However, in the 1970 *Addenda* to her list of Pontormo's drawings, Cox Rearick revised her opinion, and included the two Louvre sheets as certain works by the master. She related them to a series of red chalk studies of nudes done at the period that Pontormo was planning the decoration of the Villa Medici at Poggio a Caiano. A copy of the present drawing is preserved in the Musée d'Orléans (repr. Cox Rearick, 1970, fig. 9, attributed to Naldini).

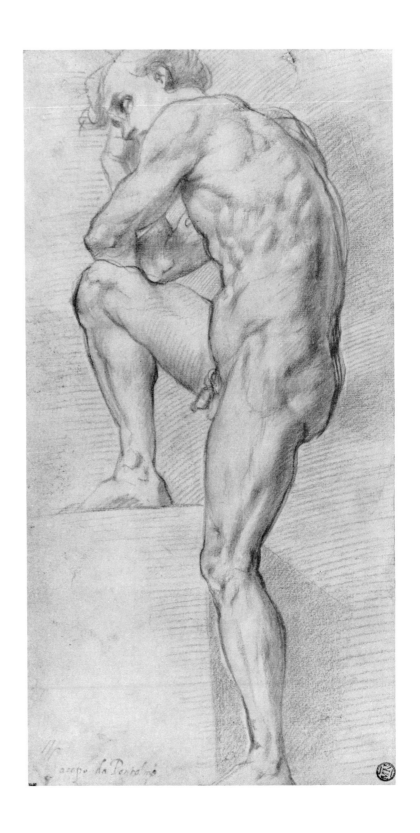

FRANCESCO PRIMATICCIO

Bologna 1504–Paris 1570

58 *Seated Figure of Juno*

Pen and brown ink, brown wash, heightened with white. Squared off in black chalk. Diam. 8¾ in. (22.3 cm.).

Inscribed in brush and white gouache at upper margin: *Bologne.*

PROVENANCE: P.-J. Mariette (Lugt 1852), his mount with cartouche: FRANCISCI PRIMATICCIO BONON. Mariette sale, Paris, 1775, part of no. 622; entered the Museum National during the Revolution. Inventaire 8551.

BIBLIOGRAPHY: L. Dimier, *Le Primatice*, Paris, 1900, p. 341, no. 38; L. Dimier, *Le Primatice*, Paris, 1928, pl. XXXII; S. Béguin, *L'Ecole de Fontainebleau*, Paris, 1960, p. 52, repr. p. 49; G. Monnier, *Le XVI⁰ siècle européen: Dessins du Louvre* (exhibition catalogue), Paris, 1965, no. 140, pl. XXXIV.

The figure seen in steep perspective, like a pendant study of Minerva also in the Louvre (Inv. 8552; R. Bacou and S. Béguin, *L'Ecole de Fontainebleau* [exhibition catalogue], Paris, 1972/73, no. 149, repr.), was utilized for the decoration of the Grotte des Pins at the Château de Fontainebleau; the frescoed figure of *Minerva* has disappeared but the *Juno* is still visible. The decorative scheme of the Grotte des Pins, which involved two medallions framing an oval composition, was probably Primaticcio's first attempt at ceiling decoration at Fontainebleau. The work was probably done around 1543, shortly after Rosso Fiorentino's death in 1540 left Primaticcio in charge of work at Fontainebleau. The steep perspective, *di sotto in su*, that characterizes the two Louvre drawings is no doubt inspired by Italian prototypes, particularly the example of Giulio Romano, with whom Primaticcio worked at the Palazzo del Te in Mantua.

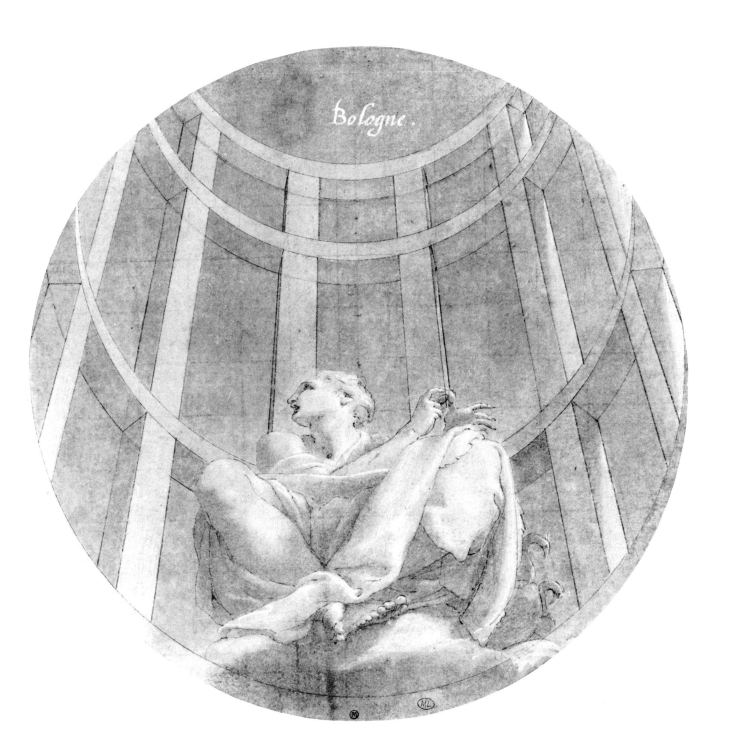

FRANCESCO PRIMATICCIO

Bologna 1504–Paris 1570

59 *The Masquerade at Persepolis*

Pen and brown ink, brown wash, heightened with white, over black chalk. Squared off in black chalk. 10 x 12 in. (25.5 x 30.5 cm.). The contours have been indented with a metal stylus.

PROVENANCE: Desneux de La Noue (Lugt 3014); Everhard Jabach (Lugt 2959), with his gold border; Cabinet du Roi from 1671. Inventaire 8568.

BIBLIOGRAPHY: Jabach Inventory, II, no. 169 (as Primaticcio); L. Dimier, *Le Primatice*, Paris, 1900, p. 433, no. 56; R. Bacou and S. Béguin, *L'Ecole de Fontainebleau* (exhibition catalogue), Paris, 1972/1973, no. 156, repr.

Study for a now lost composition known only through an engraving (Dimier, 1900, p. 507, no. 137), which formed part of the *Story of Alexander the Great*, painted between 1541 and 1544 in the Chambre de la Duchesse d'Etampes at the Château de Fontainebleau. The subject of this celebrated drawing is a legend according to which Alexander the Great, who had been born the night of the destruction by fire of the Temple of Diana at Ephesus, set fire to the palace at Persepolis in a fit of madness and intoxication on the night of a masked ball. In this remarkable nocturnal scene, worked up in delicate touches of brown wash, the light of the torches reveals the procession of figures representing cities of Antiquity descending the staircase, preceded by performing acrobats and dancers attaching bells to their ankles.

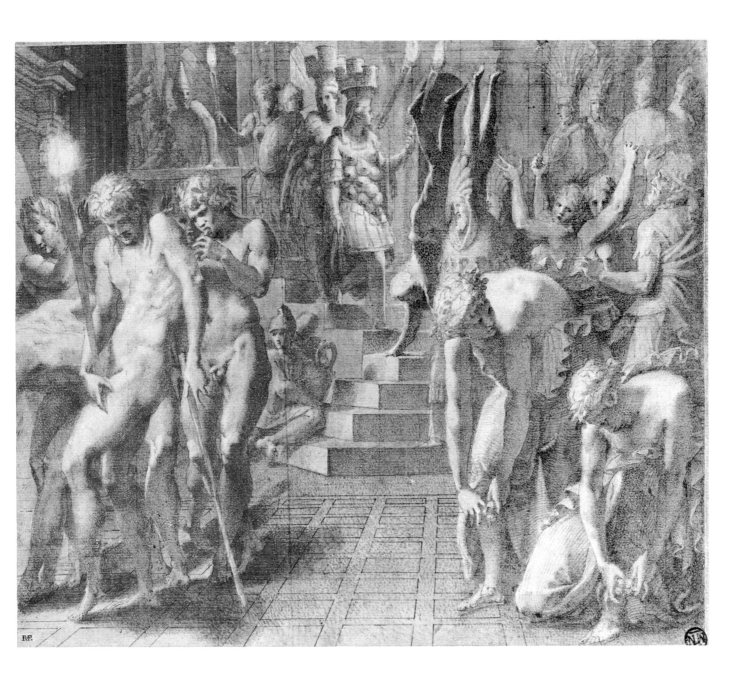

BIAGIO PUPINI

Active in Bologna 1511–after 1575

60 *The Last Supper*

Brush and brown wash, heightened with white, on brown-washed paper. 10⅛ x 17¹⁄₁₆ in. (25.8 x 43.4 cm.).

PROVENANCE: Everhard Jabach (Lugt 2959 and 2953), with his gold border; Cabinet du Roi from 1671. Inventaire 8853.

BIBLIOGRAPHY: Jabach Inventory, III, no. 412 (as Pupini).

A characteristic example of the work of Biagio Pupini, who is far better known as a draughtsman than as a painter. The Louvre possesses an important group of drawings by this Bolognese artist whose work testifies to the strong influence in Bologna in the second quarter of the sixteenth century of the work of Raphael and his students, Polidoro da Caravaggio in particular. No painting related to this study of the Last Supper has survived. Vasari devotes only a brief passage to Pupini in the chapter on the life of Bagnacavallo, with whom the former worked in the refectory of S. Salvatore and at S. Michele in Bologna (Vasari, V, pp. 177–178). Pupini's drawings, characterized by lavish white heightening on colored grounds, are stylistically related to Parmigianino's chiaroscuro prints, as N. W. Canedy has observed ("Some Preparatory Drawings by Girolamo da Carpi," *Burlington Magazine*, CXII, 1970, p. 93).

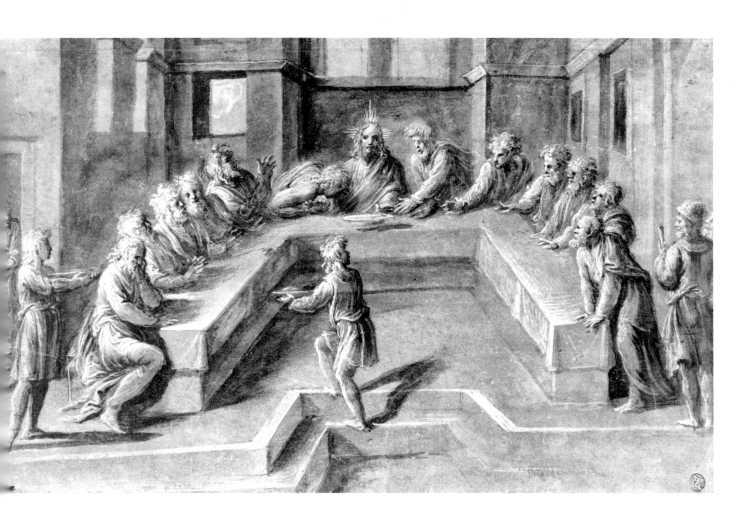

RAFFAELLO SANTI, called RAPHAEL

Urbino 1483–Rome 1520

61 *Studies of a Seated Woman Holding a Child and of a Male Head*

Metalpoint, heightened with white, on pale pink prepared paper. 8⅞ x 6 in. (22.5 x 15.2 cm.).

PROVENANCE: Marquis de Lagoy (Lugt 1710); Thomas Dimsdale; Thomas Lawrence (Lugt 2445); King William II of Holland; sale, The Hague, 1850, no. 33. Inventaire 3861.

BIBLIOGRAPHY: Reiset, 1866, no. 316; O. Fischel, *Raphaels Zeichnungen*, III, Berlin, 1922, no. 139; A. Venturi, *Choix de cinquante dessins de Raffaello Santi*, Paris, 1927, no. 17; G. Rouchès, *Musée du Louvre: Les Dessins de Raphaël*, Paris, n.d., no. 10; U. Middeldorf, *Raphael's Drawings*, New York, 1945, no. 32.

Study for the *Holy Family under a Palm Tree* in the collection of the Duke of Sutherland (Venturi, IX, 2, fig. 81), which may be one of the two paintings executed for Taddeo Taddei in Florence in 1505–06; the other is the *Madonna of the Meadow* in the Kunsthistorisches Museum, Vienna. In this drawing Raphael has studied with elegance and economy the group of the Virgin and Child at the lower right, and at the upper left the head of St. Joseph. The circular form of the painting is adumbrated in metalpoint lines at the right. The use of metalpoint on prepared paper is a drawing technique preferred by Raphael in his Florentine years. However, he utilized it in certain later drawings, such as the Louvre study for the figure of Bramante in the *Disputa* (Fischel, VI, 1925, no. 282).

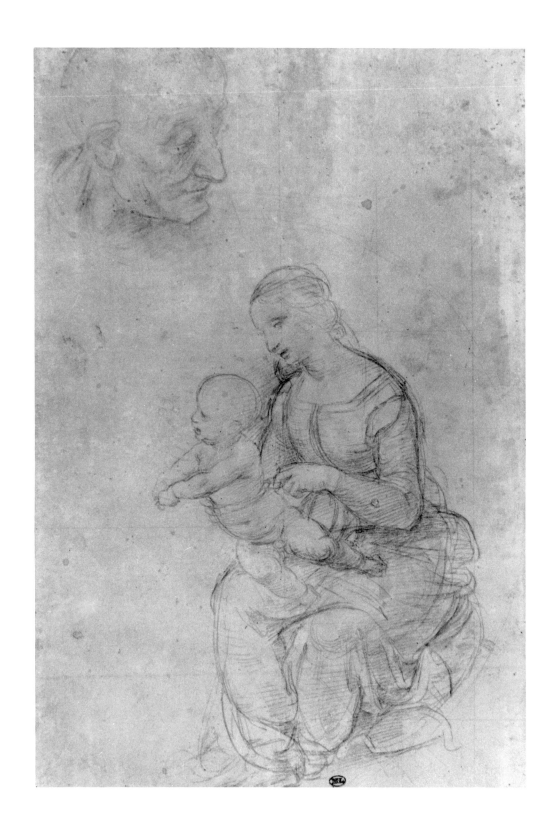

RAFFAELLO SANTI, called RAPHAEL

Urbino 1483–Rome 1520

62 *St. Catherine of Alexandria*

Black and white chalk. Contours pricked for transfer. 23⅛ x 13⅝ in. (58.7 x 34.6 cm.). The sheet composed of four pieces of paper joined together.

PROVENANCE: Everhard Jabach; Cabinet du Roi from 1671. Inventaire 3871.

BIBLIOGRAPHY: Jabach Inventory, III, no. 592 (as Raphael); Reiset, 1866, no. 323; O. Fischel, *Raphaels Zeichnungen*, IV, Berlin, 1923, no. 207, fig. 178, pl. 207 (with previous bibliography); C. Gould, *National Gallery Catalogue, The Sixteenth Century, Italian Schools*, London, 1962, p. 146; R. Bacou, *Cartons d'artistes du XV° au XIX° siècle (exhibition catalogue)*, Paris, 1974, no. 4, pl. II.

This is Raphael's cartoon for *St. Catherine of Alexandria*, a small painting on panel conserved in the National Gallery, London (Fischel, 1923, fig. 179). The classical model of the figure of the Saint is similar to several works of Raphael's Roman period, in particular the figure of *Poetry* on the vault of the Stanza della Segnatura, a figure for which there is a preparatory drawing at Windsor (Popham-Wilde, no. 792), and also the *Galatea* of 1511. The *St. Catherine* has been generally dated about 1506–07, at the time of the *Entombment* in the Borghese Gallery. For Pope-Hennessy the *St. Catherine* forms a Roman epilogue to Raphael's Florentine activity and was probably produced in 1509 (*Raphael*, London, n.d., p. 205). Cecil Gould has studied the differences between the cartoon and the painting. A sheet of sketches at the Ashmolean Museum, Oxford, has on the recto a study for the head of St. Catherine and on the verso studies for the pose of the figure (Fischel, IV, nos. 205, 204).

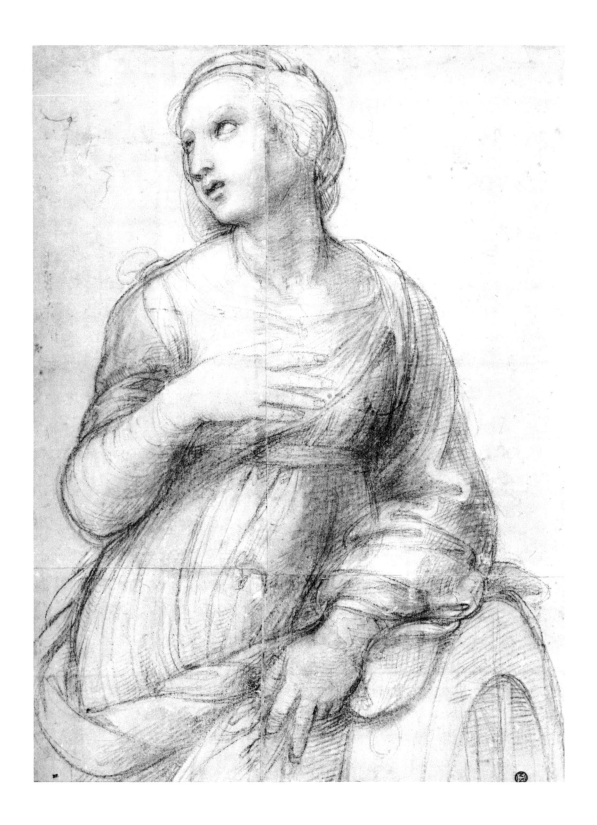

RAFFAELLO SANTI, called RAPHAEL

Urbino 1483–Rome 1520

63 *Studies of Nude Male Figures*

Pen and brown ink over red chalk.
17 x 11¾₁₆ in. (43.2 x 28.5 cm.).

Inscribed in pen and brown ink at center of
lower margin: *Raphael*; numbered in pen
and brown ink: *101*.

PROVENANCE: Viti-Antaldi (Lugt 2245);
entered the Museum National during the
Revolution.
Inventaire 3847.

BIBLIOGRAPHY: J. D. Passavant, *Raphaël
d'Urbin et son père Giovanni Santi*, II,
Paris, 1860, p. 472, no. 351; O. Fischel,
Raphaels Zeichnungen, V, Berlin, 1924,
no. 224; Pouncey-Gere, 1962, pp. 46–47;
F. Viatte, *Le XVIᵒ siècle européen:
Dessins du Louvre* (exhibition catalogue),
Paris, 1965, no. 41, pl. XII (with previous
bibliography).

Fischel pointed out that the figures sketched on this sheet are studies for the Adam in the *Temptation of Adam and Eve*, one of the four rectangular compositions separating the medallions in the ceiling of the Stanza della Segnatura in the Vatican. John Shearman has devoted a study to the chronology and iconographical program of this decorative scheme, on which Raphael worked during the winter of 1509 ("Raphaël's Unexecuted Projects for the Stanze," *Walter Friedländer zum 90 Geburtstag,* Berlin, 1965, pp. 159–160). The seated figure studied at the upper left has been transformed into a St. John the Baptist by the addition of a cross.

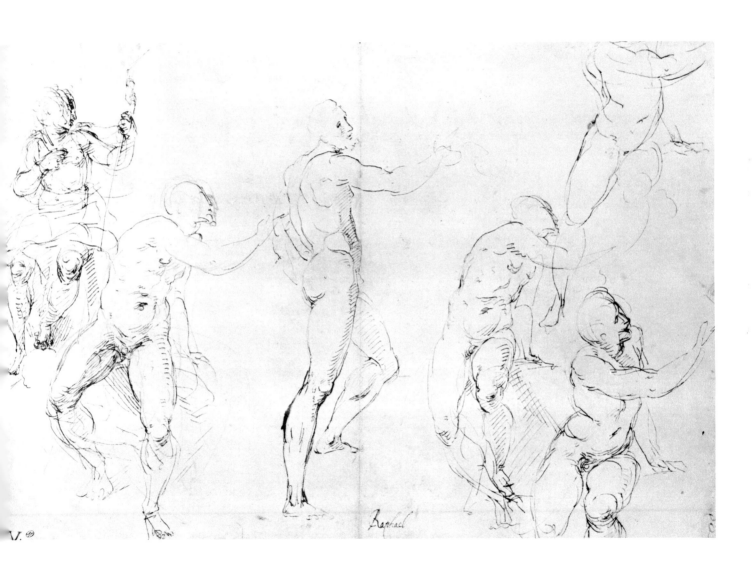

Raphael

V.

RAFFAELLO SANTI, called RAPHAEL

Urbino 1483–Rome 1520

64 *Head of an Avenging Angel*

Black chalk, heightened with white, on brown paper. 10⁹⁄₁₆ x 12¹⁵⁄₁₆ in. (26.8 x 32.9 cm.). Lower portion of sheet replaced.

Inscribed at lower right: *101*.

PROVENANCE: Pierre Crozat; Crozat sale, Paris, 1741, part of no. 114; P.-J. Mariette, his mount with inscription: RAPHAEL URBINAS. *Unius ex Angelis Ultoribus Heliodorum é Templo eijicientibus caput in Palatio Vaticano*; Mariette sale, Paris, 1775, part of no. 694; Cabinet du Roi. Inventaire 3853.

BIBLIOGRAPHY: Reiset, 1866, no. 312; K. Oberhuber, *Raphaels Zeichnungen*, IX, Berlin, 1972, no. 401, pl. 6 (with previous bibliography); R. Bacou, *Cartons d'artistes du XV° au XIX° siècle* (exhibition catalogue), Paris, 1974, no. 6, pl. IV.

A cartoon for the head of one of the two avenging angels in the *Expulsion of Heliodorus*, a fresco in the Stanza d'Eliodoro in the Vatican, the decoration of which was undertaken in 1511. The Louvre also possesses the cartoon for the head of the second avenging angel driving out Heliodorus (Inv. 3852; Oberhuber, no. 400, pl. 5). The two cartoons were acquired by Mariette at the Crozat sale. Their authenticity was occasionally doubted in the nineteenth century, but today they generally are accepted as full-scale cartoon fragments by Raphael himself. They may have been amongst the cartoons seen by Giorgio Vasari in the house of Francesco Massini at Cesena (Vasari, IV, p. 346), along with the cartoon for the head of the horse in the *Expulsion of Heliodorus* conserved in the Ashmolean Museum, Oxford (Parker, 1956, no. 556, pl. CXXXV).

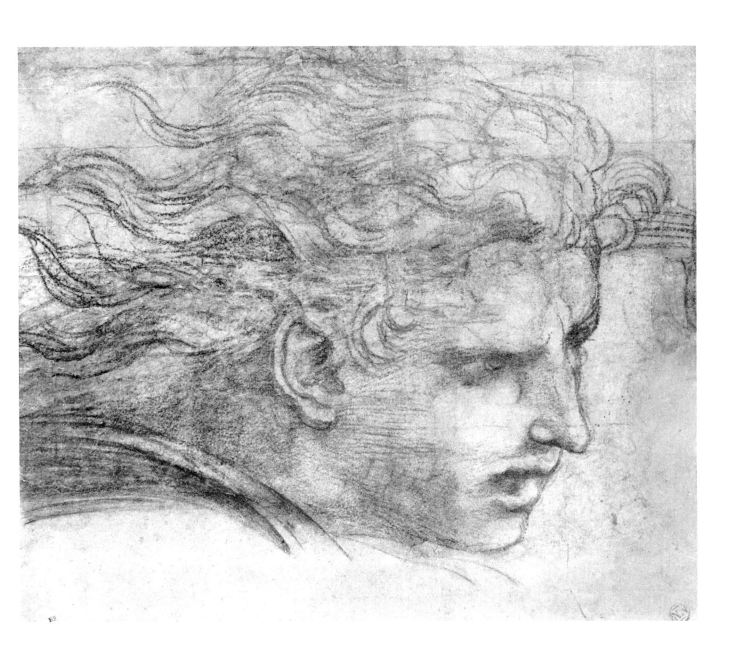

FRANCESCO DEI ROSSI, called FRANCESCO SALVIATI

Florence 1510–Rome 1563

65 *Christ Showing His Wound to the Doubting Thomas*

Pen and brown ink, brown wash, over traces of black chalk. 12⅟₁₆ x 10³⁄₁₆ in. (30.6 x 25.9 cm.).

PROVENANCE: Everhard Jabach (Lugt 2961); Cabinet du Roi from 1671. Inventaire 1644.

BIBLIOGRAPHY: Jabach Inventory, I, no. 92 (as Salviati); Monbeig-Goguel, 1972, no. 145, repr.

Although it is not a preparatory study for the painting, this drawing is probably connected with the *Incredulity of St. Thomas* in the Louvre (Département des Peintures, Inv. 1484), which comes from the church of the Jacobins in Lyons where it ornamented the altar of the chapel of the Guadagni family. Tomaso Guadagni, who, according to Vasari, brought the painting to France, was a *conseiller* of King François I. Well documented by Vasari, the painting is datable around 1547 (Vasari, VII, p. 28). In 1958 the Louvre acquired Salviati's *modello* for this composition, with the text of the contract inscribed on the sheet (Inv. RF 31.139; Monbeig-Goguel, no. 146, repr.). Another drawing in the Louvre from the Jabach collection, mounted on a page from Vasari's *Libro de' Disegni*, shows Christ opening His wound as He does in the present version, but with the figures of Christ and St. Thomas represented standing and alone (Inv. 1642; ibid., no. 147). The present drawing is characteristic of the tormented, unreal style of the artist, expressed in the treatment of the faces and the agitation of the drapery.

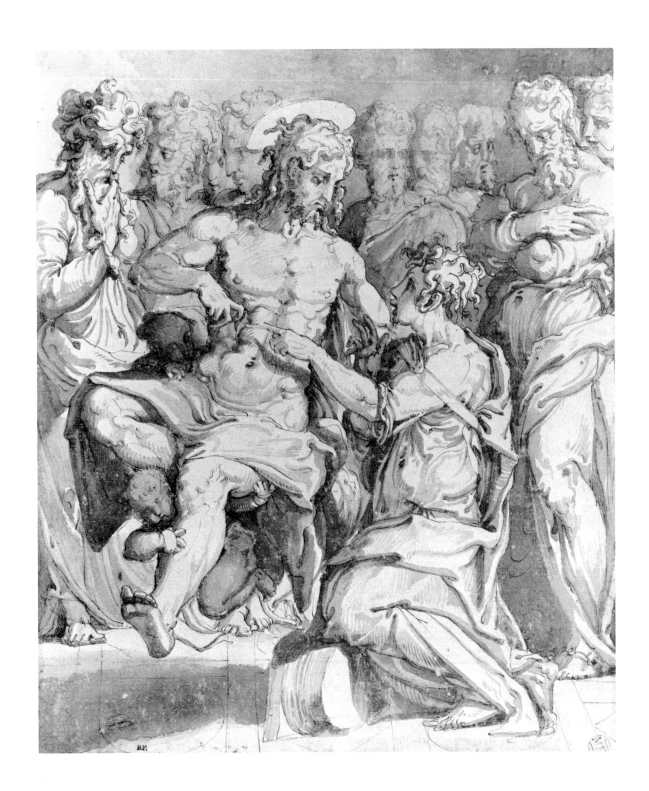

ANDREA DEL SARTO

Florence 1486–Florence 1530

66 *Study of a Seated Man*

Black chalk. 9½ x 5⅞ in. (24.2 x 15.0 cm.).

PROVENANCE: Giorgio Vasari, with cartouche: ANDREA DEL SARTO; Pierre Crozat; P.-J. Mariette (Lugt 1852); Mariette sale, Paris, 1775, part of no. 705; Cabinet du Roi. Inventaire 1680.

BIBLIOGRAPHY: Mariette, *Abecedario*, V, p. 185; Berenson, 1961, I, p. 413; II, no. 145; III, figs. 787, 788; Freedberg, 1963, p. 140, fig. 167; Shearman, 1965, I, pl. 139; II, pp. 372–373; R. Bacou, *P.-J. Mariette* (exhibition catalogue), Paris, 1967, no. 8.

A superb example of Andrea's use of black chalk. The drawing is a study for the figure of Zacharias writing the name of his son in the *Birth of St. John the Baptist,* painted in 1526 and forming part of a series of monochrome frescoes decorating the Chiostro dello Scalzo in Florence (repr. Shearman, 1965, II, pl. 138b). In the eighteenth century Mariette had already noted the connection between the fresco and this drawing, which, before it passed into his possession, had belonged to Vasari and to Crozat. The British Museum possesses a red chalk study for the whole composition of the *Birth of the Baptist* (repr. Shearman, 1965, I, pl. 138a; II, p. 361).

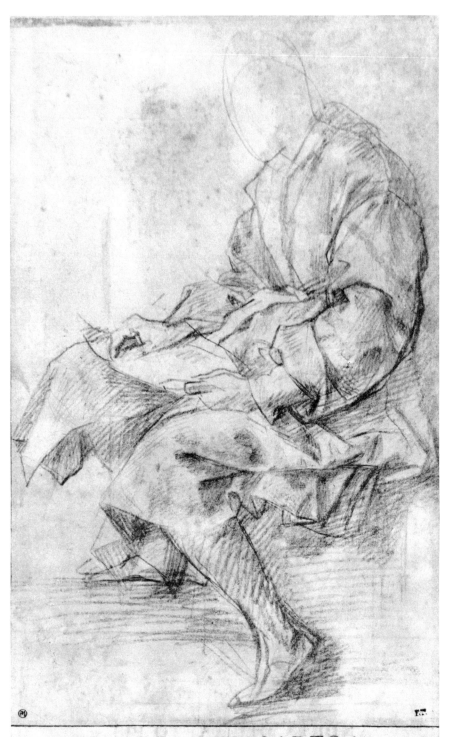

ANDREA DEL SARTO :~

ANDREA DEL SARTO

Florence 1486–Florence 1530

67 *Studies of a Dog*

Red chalk. 7⁷⁄₁₆ x 9¹⁵⁄₁₆ in. (19.0 x 25.3 cm.).

PROVENANCE: Everhard Jabach (Lugt 2961);
Cabinet du Roi from 1671.
Inventaire 1687.

BIBLIOGRAPHY: Berenson, 1961, I, p. 416; II,
no. 150 A; III, figs. 804, 805; Freedberg,
1963, p. 103, figs. 110, 111; Shearman,
1965, I, pl. 82 a, b; II, p. 375; R. Bacou,
*Le XVIᵒ siècle européen: Dessins du
Louvre* (exhibition catalogue), Paris, 1965,
no. 82, pl. XXIII; R. Bacou and F. Viatte,
Dessins du Louvre: Ecole italienne, Paris,
1968, no. 34, repr.

Studies for the dog that runs down the steps at the center of the *Tribute to Caesar*, a fresco in the Villa Medici at Poggio a Caiano, commissioned by Pope Leo X and executed in 1521 (repr. Shearman, 1965, I, pls. 74, 81). Work on the fresco was interrupted at the death of the Pope in December, 1521, and the painting was completed only in 1532 by Alessandro Allori. The Landesmuseum in Darmstadt possesses another sheet of red chalk studies for the same dog and for the monkey seated on the steps (repr. Shearman, 1965, I, pl. 83; II, p. 325). These sketches from life testify to Andrea's mastery as a draughtsman and to his extraordinary ability to record figure movement.

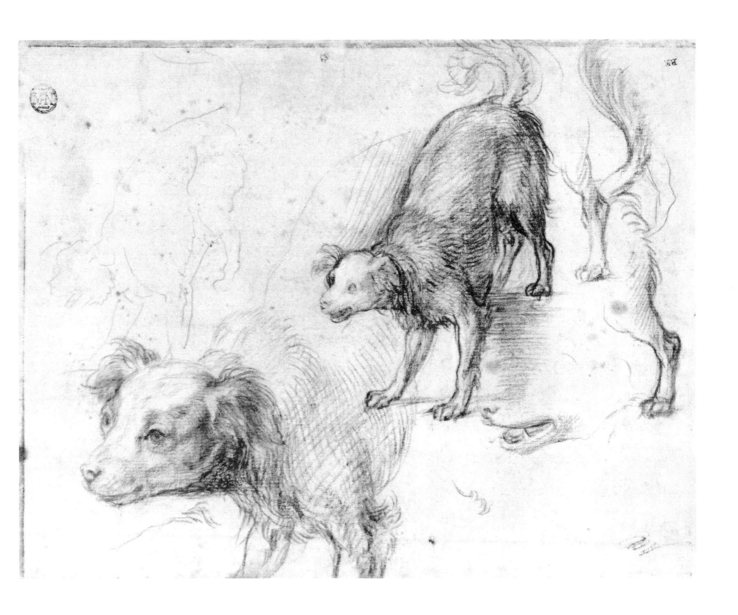

ANDREA DEL SARTO

Florence 1486–Florence 1530

68 *Head of a Man Looking Upward*

Red chalk. 7¹¹⁄₁₆ x 6⅛ in. (19.5 x 15.6 cm.).

Inscribed in pen and brown ink at lower right: *turpilio.*

PROVENANCE: Cabinet du Roi.
Inventaire 1685.

BIBLIOGRAPHY: Reiset, 1866, no. 41; H. Guinness, *Andrea del Sarto,* London, 1899, p. 80; L. Becherucci, *Andrea del Sarto,* Milan, 1955, pl. 32; J. Shearman, "Andrea del Sarto's Two Paintings of the Assunta," *Burlington Magazine,* CI, 1959, p. 129; Berenson, 1961, I, p. 427; II, no. 149; III, fig. 849; Freedberg, 1963, pp. 110, 118, fig. 117; Shearman, 1965, I, p. 158, pl. 102 a; II, pp. 252, 374 (with previous bibliography); A. Forlani-Tempesti, *Capolavori del Rinascimento,* Milan, 1970, pl. XXVIII.

Guinness was the first to identify this drawing as a study for an apostle standing at the left in the *Assumption* painted for Bartolommeo Panciatichi and now in the Palazzo Pitti (repr. Shearman, 1965, I, pl. 102). On the other hand, Berenson suggested that the figure is a study for the St. Joseph in the *Madonna della Scala* in the Prado (repr. ibid., pl. 99b). In 1955 Becherucci suggested that the drawing was indeed used in both compositions, a fact which reinforces Shearman's thesis that the Panciatichi *Assumption,* generally dated to Andrea's last years, is in fact a work contemporary with the *Madonna della Scala* of 1522–23. The date of 1522 for the beginning of work on the *Assumption* is accepted by Freedberg, who points out that on the reverse of this drawing there is a study, visible in transparency, for the right hand of the Virgin in the *Madonna della Scala.*

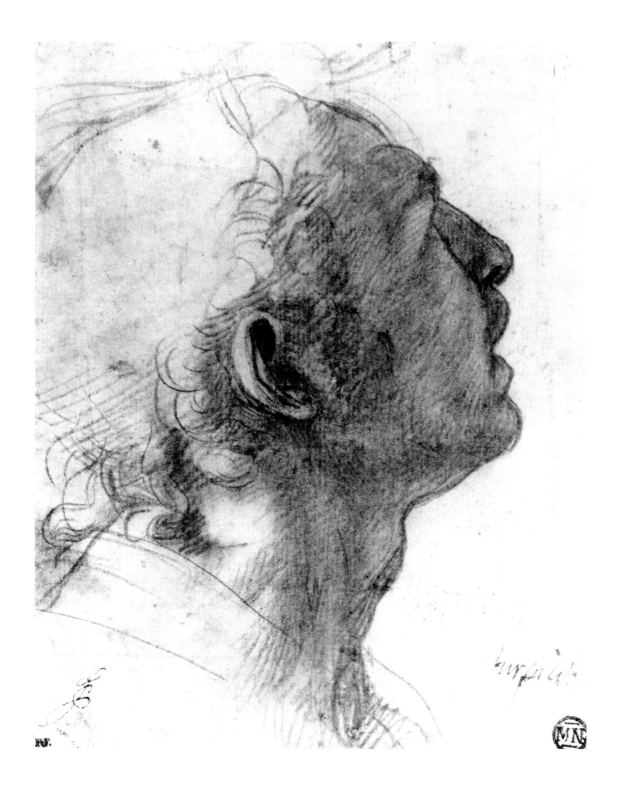

SEBASTIANO DEL PIOMBO

Venice, about 1485–Rome 1547

<div style="text-align: center;">

69 *Standing Female Nude*

</div>

Black chalk, heightened with white, on blue paper. 13⅞ x 7⁷⁄₁₆ in. (35.3 x 18.9 cm.).

PROVENANCE: Everhard Jabach (Lugt 2959); Cabinet du Roi from 1671. Inventaire 10.816.

BIBLIOGRAPHY: P. Pouncey, "A Study by Sebastiano del Piombo for the Martyrdom of S. Agatha," *Burlington Magazine,* XCIV, 1952, p. 116, fig. 1; Berenson, 1961, II, no. 2497 C; III, fig. 702; P. Pouncey, "B. Berenson, *I Disegni dei pittori fiorentini*" (review), *Master Drawings,* II, 3, 1964, p. 291; R. Bacou, *Le XVI° siècle européen: Dessins du Louvre* (exhibition catalogue), Paris, 1965, no. 100, pl. xxv; R. Bacou and F. Viatte, *Dessins du Louvre: Ecole italienne,* Paris, 1968, no. 31, repr.

This drawing was identified in 1952 by Philip Pouncey as a study for the figure of the Saint in the *Martyrdom of St. Agatha,* a painting dated 1520 and now in the Palazzo Pitti, Florence; the attribution of the drawing to Sebastiano was recorded by Berenson (painting and drawing repr. Berenson, 1961, III, figs. 701, 702). In the painted composition St. Agatha is represented in the same position, but only three-quarter length, with her hips draped. By the Saint's right breast are lightly sketched the executioner's tongs. If the female type reveals the profound influence of Michelangelo on Sebastiano after the latter's arrival in Rome in 1511, the Venetian character of the drawing is underlined not only by the technique used, but also by the luminous, pictorial treatment of the ample form.

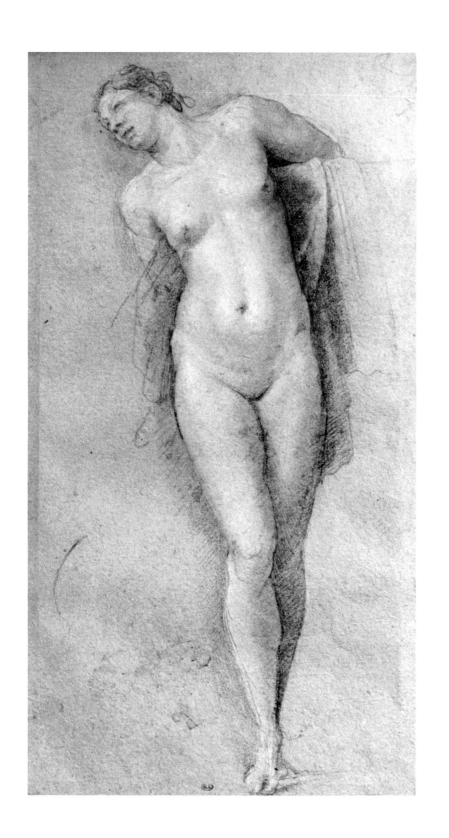

GIOVANNI ANTONIO BAZZI, called SODOMA

Vercelli 1477–Siena 1549

70 *Project for a Ceiling Decoration*

Pen and brown ink, brown wash, heightened with white, on beige paper. 11¾ x 22⁷⁄₁₆ in. (29.8 x 57.0 cm.).

PROVENANCE: Nicholas Lanier (Lugt 2885); Peter Lely (Lugt 2092); Nathaniel Hone (Lugt 2793); Joshua Reynolds (Lugt 2364); Thomas Lawrence (Lugt 2445); Hippolyte Destailleur; Destailleur sale, Paris, May 19, 1896, no. 4; E. Calando (Lugt 837); acquired by the Cabinet des Dessins in 1970.
Inventaire RF 34.503.

BIBLIOGRAPHY: H. Cust, *G. A. Bazzi*, London, 1906, p. 226, note 2; E. Carli, *Giovanni Antonio Bazzi detto Sodoma* (exhibition catalogue), Vercelli-Siena, 1950, under no. 10.

This important ceiling design by Sodoma, whose surviving drawings are rare, was only recently rediscovered and acquired by the Louvre. In the center of the vault figures a *Rape of Ganymede* of circular form, and on the left is projected a *Fall of Phaeton* in an octagonal frame. Surrounding this central area, narrative scenes in settings of *trompe-l'œil* architecture are separated by niches crowned by cockleshells and occupied by single figures (Charity, Leda, and a Warrior) or groups (the Three Graces). At the center of the right side figures lean over a balustrade.

Another ceiling project by Sodoma in the Uffizi (1644 E) with a *Fall of Phaeton* at the center appears to be related to the same decorative scheme for which the present drawing is a study (Carli, 1950, no. 101, repr. p. 58; A. Forlani-Tempesti, *Capolavori del Rinascimento*, Milan, 1970, fig. 50). The two drawings differ in many ways, but both include the *Fall of Phaeton* and representations of a River God, Romulus and Remus with the She-Wolf, and the Three Graces.

Cust and Carli associated the Uffizi drawing with a *Fall of Phaeton* painted, according to Vasari, for Lorenzo de' Medici's house in Volterra. However, Vasari seemed to refer to an easel picture rather than a ceiling decoration. Anna Forlani-Tempesti, on the other hand, convincingly suggests on the basis of iconographical elements that the decorative project was intended for a Sienese palace. There is a striking similarity between the architecture of the niches in the two drawings and that of Sodoma's painted niches with figures of St. Victor and St. Ansanius in the Palazzo Pubblico, Siena (repr. Carli, 1950, pp. 70, 71).

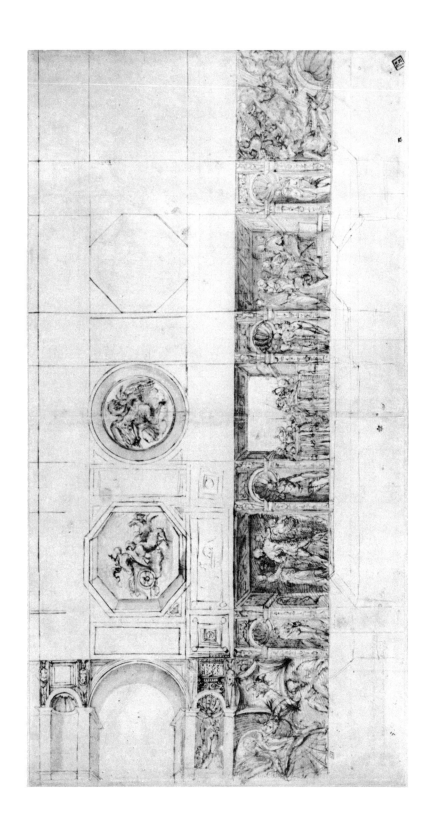

GIOVANNI ANTONIO SOGLIANI

Florence 1492–Florence 1544

71 *Male Figure Facing Right*

Black chalk. 7⁷⁄₁₆ x 6¾ in. (19.0 x 17.2 cm.).

PROVENANCE: Cabinet du Roi.
Inventaire 2722.

BIBLIOGRAPHY: R. Bacou, *Dessins de maîtres florentins et siennois* (exhibition catalogue), Paris, 1955, no. 29; R. Bacou, "A Group of Drawings by Sogliani," *Master Drawings*, I, 1, 1963, pp. 41–43, pl. 37; P. Pouncey, "B. Berenson, *I Disegni dei pittori fiorentini*" (review), *Master Drawings*, II, 3, 1964, p. 292.

Study for the saint kneeling in the left foreground in a painting by Sogliani representing the Martyrdom of St. Acathius, a Cappadocian centurion, who was converted to Christianity with ten thousand of his soldiers and then crucified with them on Mount Ararat (repr. Bacou, 1963, fig. 1). Commissioned by Alfonsina Orsini, widow of Piero de' Medici, for the altar of the Cappella dei Martiri in S. Salvatore di Camaldoli in Florence, this painting, signed and dated 1521, is now in the church of S. Lorenzo; the predella, with three scenes of the Life of St. Acathius painted by Bacchiacca, is in the Uffizi (repr. Venturi, IX, figs. 339–41). Six studies in the Uffizi and in the Louvre are connectible with Sogliani's composition. If the influence of Fra Bartolommeo is apparent in the way in which drapery is treated in these drawings, the modeling of the nude figure in the present drawing testifies to the personal evolution of Sogliani at the time of the first manifestations of Florentine mannerism.

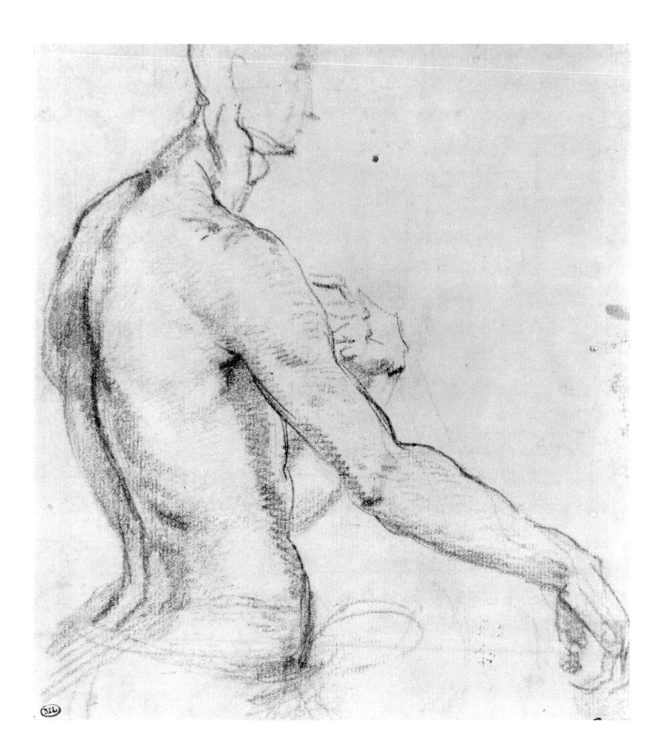

PELLEGRINO TIBALDI

Puria di Valsolda 1527–Milan 1596

72 *Hercules on the Funeral Pyre*

Pen and brown ink, brown wash, heightened with white, over traces of red chalk, on beige paper. Partially squared off in black chalk. 9³⁄₁₆ x 8⅞ in. (23.4 x 22.5 cm.).

Inscribed in pencil at lower margin: *hercule mourant.*

PROVENANCE: P.-J. Mariette (Lugt 1852); Mariette sale, Paris, 1775, part of no. 741; entered the Museum National during the Revolution.
Inventaire 9049.

BIBLIOGRAPHY: E. Bodmer, "Nuove attribuzioni a Pellegrino Tibaldi," *Rivista d'Arte,* 1937, p. 20; G. Briganti, *Il Manierismo e Pellegrino Tibaldi,* Rome, 1945, pp. 80, 124; S. Béguin, *P.-J. Mariette* (exhibition catalogue), Paris, 1967, no. 138.

Study for a fresco painted by Tibaldi above the chimney in a room in the Palazzo Poggi, Bologna, a building begun in 1549 for Cardinal Giovanni Poggi and his brother. This fresco of trapezoidal form representing Hercules Expiring on a Funeral Pyre with a Genius above Holding His Sword, is in a room on the ground floor of the palace close to the rooms decorated by Tibaldi with the Story of Ulysses. At the right in the drawing appear Tibaldi's indications for the ornamental stucco border of the fresco. It was Giulio Briganti who identified this drawing, dating it around 1555. Mariette owned several sheets by Tibaldi (sale, 1775, nos. 741–743) and said of the artist's drawings: "Comme il a travaillé en Espagne, ses desseins sont devenus fort rares." (*Abecedario,* V, p. 298).

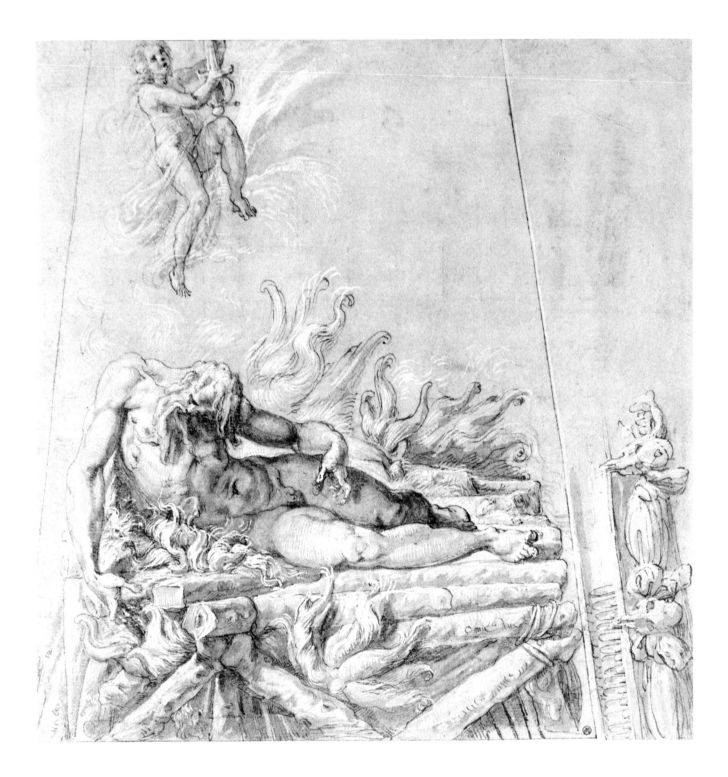

TADDEO ZUCCARO

Sant'Angelo in Vado 1529–Rome 1566

73 *St. John the Evangelist in a Pendentive*

Pen and brown ink, black and red chalk, heightened with white. Squared off in black chalk. 13⁹⁄₁₆ x 10¼ in. (34.5 x 26.1 cm.).

Inscribed in pen and brown ink: *Tadeo Zuccaro.*

PROVENANCE: Cardinal Santa Croce; Pierre Crozat; entered the Museum during the Revolution.
Inventaire 11.897.

BIBLIOGRAPHY: J. A. Gere, *Dessins de Taddeo et Federico Zuccaro,* (exhibition catalogue), Paris, 1969, no. 13, pl. IV; J. A. Gere, *Taddeo Zuccaro, His Development Studied in His Drawings,* London, 1969, p. 198, no. 202, pl. 59.

Study for the pendentive to the left above the altar of the Mattei Chapel in S. Maria della Consolazione, Rome, representing St. John the Evangelist with his attribute, an eagle (Gere, 1969, pl. 65). According to Vasari the decoration of this chapel, with scenes of the Passion of Christ, occupied Taddeo for four years and was completed in 1556; thus the work must have been begun shortly after 1553, when Taddeo returned to Rome from Urbino. The Louvre possesses two other preparatory studies for this ensemble (Inv. 6475 and 11.816; Gere, exhibition catalogue, 1969, nos. 14–15). The frescoes survive, but have been much damaged by humidity. A drawing for the figure of St. Luke in another pendentive is in the collection of Lord Methuen at Corsham Court, Wiltshire. This study is a perfect illustration of Taddeo's style in the 1550s, when he turned away from the example of Raphael and his school and sought capricious, unreal effects that are paralleled in the early works of Tibaldi in Rome and the Roman paintings of Francesco Salviati.

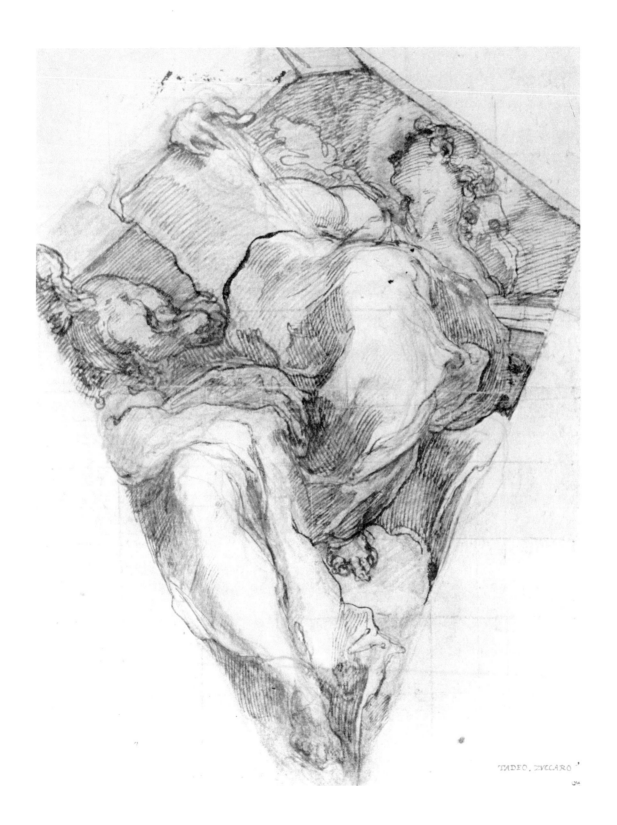

TADEO. ZVCCARO

TADDEO ZUCCARO

Sant'Angelo in Vado 1529–Rome 1566

74 *The House of Sleep*

Pen and brown ink, brown wash. Diam.
10⁷⁄₁₆ in. (26.5 cm.).

PROVENANCE: Everhard Jabach (Lugt 2961);
Cabinet du Roi from 1671.
Inventaire 10.481.

BIBLIOGRAPHY: Jabach Inventory, II, no. 304
(as Zuccaro); R. Bacou, *Le XVIᵒ siècle
européen: Dessins du Louvre* (exhibition
catalogue), Paris, 1965, no. 129, pl. XXXI;
J. A. Gere, *Dessins de Taddeo et Federico
Zuccaro* (exhibition catalogue), Paris, 1969,
no. 23; J. A. Gere, *Taddeo Zuccaro, His
Development Studied in His Drawings*,
London, 1969, p. 195, no. 194, pl. 140.

Until recently classed amongst the anonymous Italian drawings,
though it had been attributed to Zuccaro in the seventeenth cen-
tury, this drawing was identified by J. A. Gere as a study, with
some variations, by Taddeo Zuccaro for a circular fresco in one of
the pendentives in the Stanza di Aurora in the Palazzo Farnese at
Caprarola, where Taddeo worked for Cardinal Alessandro Farnese
from 1559. The fresco represents Somnus with Phantasos, Mor-
pheus, and Icelos, and follows the iconographical program estab-
lished on November 21, 1562, by the humanist Annibale Caro
(Gere, exhibition catalogue, 1969). The drawing is specifically de-
scribed in the manuscript inventory of the Jabach collection under
the name of Zuccaro: "Une femme couchée sur un lit, où il y a
quantité de chimères autour d'elle. . ." The high finish of the draw-
ing is rather unusual for Taddeo, who shows great imagination in
this evocation of an allegory inspired by Ovid's *Metamorphoses*.
The drawing recalls the themes treated at about the same date,
though in an entirely different spirit, by Lelio Orsi (see Nos. 37
and 38). Gere has pointed out that a copy of this drawing is in the
Uffizi (Inv. 14027 F).

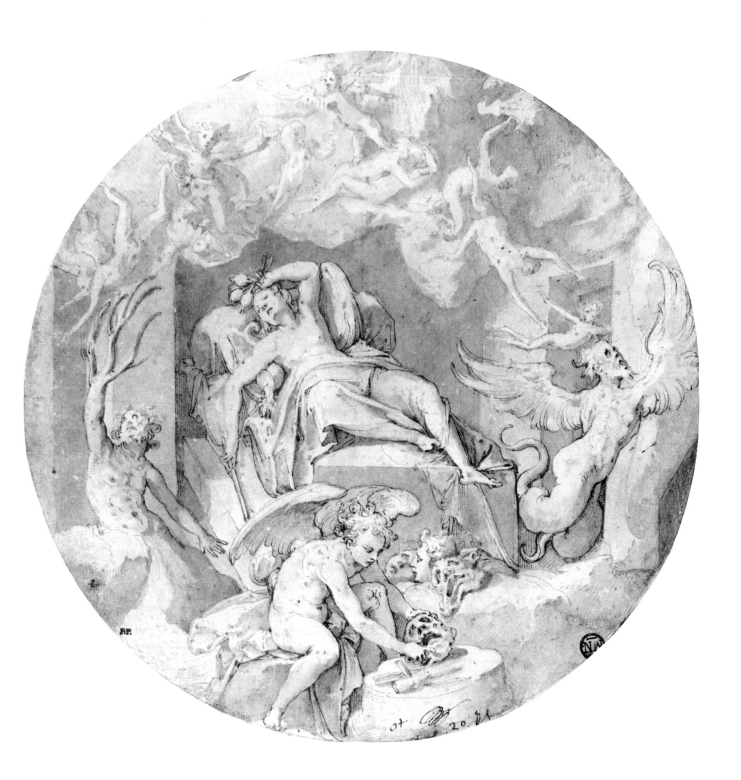

Works Cited in Abbreviated Form

Mariette, *Abecedario*

P. de Chennevières and A. de Montaiglon, *Abecedario de Mariette et autres notes inédites de cet amateur sur les arts et les artistes. (Archives de l'Art Français)*, 6 vols., 1851–1860.

Bartsch

Adam Bartsch, *Le Peintre graveur*, 21 vols., Vienna, 1803–1821.

Berenson, 1961

Bernard Berenson, *I Disegni di pittori fiorentini*, 3 vols., Milan, 1961.

Dussler, 1959

Luitpold Dussler, *Die Zeichnungen des Michelangelo*, Berlin, 1959.

Freedberg, 1963

S. J. Freedberg, *Andrea del Sarto*, 2 vols., Cambridge, Mass., 1963.

Goldscheider, 1951

Ludwig Goldscheider, *Michelangelo Drawings*, London, 1951.

Hartt, 1958

Frederick Hartt, *Giulio Romano*, 2 vols., New Haven, 1958.

Jabach Inventory

Manuscript Inventory of the Jabach Collection preserved in the Cabinet des Dessins, Musée du Louvre.
> I.—*Inventaire manuscrit de la collection Jabach. Escole florentine.*
> II.—*Inventaire manuscrit de la collection Jabach. Desseins des Escoles de Venise et Lombardie.*
> III.—*Inventaire manuscrit de la collection Jabach. Escoles de Raphael.*

Lugt

Frits Lugt, *Les Marques de collections de dessins et d'estampes . . .* , Amsterdam, 1921; *Supplément*, The Hague, 1956.

Monbeig-Goguel, 1972

Catherine Monbeig-Goguel, *Inventaire Général des Dessins Italiens du Musée du Louvre. I. Vasari et son temps*, Paris, 1972.

Parker, 1956

K. T. Parker, *Catalogue of the Drawings in the Ashmolean Museum, Oxford, II, Italian Schools, 1956.*

Popham, 1952

A. E. Popham, *The Drawings of Parmigianino*, London, 1952.

Popham, 1971

A. E. Popham, *Catalogue of the Drawings of Parmigianino*, 3 vols., New Haven and London, 1971.

Popham-Wilde, 1949

A. E. Popham and Johannes Wilde, *The Italian Drawings of the XV and XVI Centuries in the Collection of His Majesty the King at Windsor Castle*, London, 1949.

Pouncey-Gere, 1962

Philip Pouncey and J. A. Gere, *Italian Drawings in the Department of Prints and Drawings in the British Museum. Raphael and his Circle*, 2 vols., London, 1962.

Reiset, 1866

F. Reiset, *Notice des Dessins, Cartons, Pastels, Miniatures et Emaux exposés dans les salles du 1er et du 2ème étage au Musée Impérial du Louvre. Première Partie, Ecoles d'Italie, Ecoles Allemande, Flamande et Hollandaise*, Paris, 1866.

Shearman, 1965

John Shearman, *Andrea del Sarto*, 2 vols., Oxford, 1965.

Thode

Henry Thode, *Michelangelo, Kritische Untersuchungen über seine Werke*, Berlin, 3 vols., 1908–13.

Tolnay, *Michelangelo* I

Charles de Tolnay, *The Youth of Michelangelo*, Princeton, 1943.

Tolnay, *Michelangelo* II

Charles de Tolnay, *The Sistine Ceiling*, Princeton, 1945.

Tolnay, *Michelangelo* III

Charles de Tolnay, *The Medici Chapel*, Princeton, 1948.

Tolnay, *Michelangelo* IV

Charles de Tolnay, *The Tomb of Julius II*, Princeton, 1954.

Tolnay, *Michelangelo V* Charles de Tolnay, *The Final Period*, Princeton, 1960.

Vasari Giorgio Vasari, *Le Vite de più eccellenti pittori, scultori ed architettori scritte da ... con nuovo annotazioni e commenti di Gaetano Milanesi*, 9 vols., Florence, 1906.

Venturi Adolfo Venturi, *Storia dell'arte italiana,* 11 vols., Milan, 1901–39.

Weigel Rudolph Weigel, *Die Werke der Maler in ihren Handzeichnungen*, Leipzig, 1865.

Wilde, 1953 Johannes Wilde, *Italian Drawings in the Department of Prints and Drawings in the British Museum. Michelangelo and his Studio*, London, 1953.